CUT IN HALF

CUT IN HALF

The Hidden World Inside Everyday Objects

By **MIKE WARREN**

Photographs by **JONOTHAN WOODWARD**

CHRONICLE BOOKS
SAN FRANCISCO

Library of Congress Cataloging-in-Publication Data

Names: Warren, Mike, 1980– author. | Woodward, Jonothan (Photographer),
 illustrator.
Title: Cut in half : the hidden world inside everyday objects / Mike Warren ;
 photographs by Jonothan Woodward.
Description: San Francisco : Chronicle Books, [2018]
Identifiers: LCCN 2018006964 | ISBN 9781452168623
(hardcover : alk. paper)
Subjects: LCSH: Household appliances—Design and construction—Juvenile
 literature. | Inventions—Design and construction—Juvenile literature. |
 Industrial design—Juvenile literature.
Classification: LCC TX298 .W37 2018 | DDC 683/.8—dc23 LC
record available at https://lccn.loc.gov/2018006964

Manufactured in China

PHOTOGRAPHS by Jonothan Woodward
PHOTOGRAPHS on pages 9–13, 140 by Mike Warren
DESIGN by Neil Egan

10 9 8 7 6 5 4 3 2

Chronicle Books LLC
680 Second Street
San Francisco, California 94107
www.chroniclebooks.com

For curious minds of all ages.

Contents

INTRODUCTION

I am a product designer and fabricator by trade, and get to use some fun industrial tools as part of my job. One of those tools is a waterjet cutter, a computer-controlled industrial machine that uses a high-pressure jet of water mixed with garnet to cut all manner of sheet goods like steel, glass, tile, and high density plastic. While the jet of water is the medium, it's the very fine grit of the garnet that does the cutting, through abrasion. The water is pressurized to 60,000 psi (pounds per square inch) and can cut solid steel up to 4″ (10cm) thick, and is great at cutting repeatable, highly precise geometric shapes in flat materials. It's quite impressive, for those into nerdy tools.

One day, as I was cutting on the machine, I got to thinking, *what if I put something else under the cutting nozzle?* The results are what you see in this book.

Since early 2016, I have been using the power of this machine to cut into everyday objects and then showcase the insides on my YouTube channel Cut in Half (youtube.com/c/cutinhalf). The format of the channel is deliberately straightforward: demonstrate the object, cut the object, reveal the insides. Simple, clear, no narration, with a focus on the object and the interior architecture. Making this book presented a different opportunity. The still images in these pages offer something the videos do not—a chance to really pore over the intricate details of the cut objects up close. We can explore and explain some of what's going on in there, what we see and how it works. To take full advantage of this, all the objects here have been cut and photographed exclusively for this book.

As a kid I used to take things apart all the time, just to see how they work. Like a lot of kids, I wanted to know the why of everything I picked up. Why does a phone ring? Why do my electronics get hot? Why does my mixtape sometimes get eaten by my boom box? All

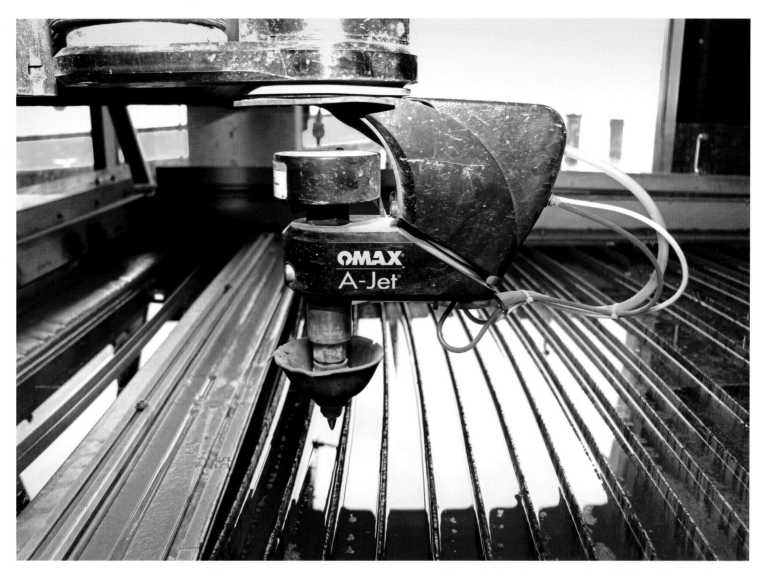

questions I could answer, if I just knew what was going on inside. Years later some of those answers still elude me. (I may never know why my ABBA cassette was destroyed in my boom box.)

As an adult, my curiosity still hasn't been satisfied—it never really will be—but now I have access to this amazing device that allows me to slice into and peek inside the stuff all around us. My aim is to reveal every-day items and showcase the beauty of what we normally don't get to see. As a lifelong learner, I find it's always interesting to see how design problems are overcome. Even when I think I know how something works, I usu-ally learn something new with every item I cut open. The kid in me can't get enough of it.

The cutting head at rest over the pool. The yellow cup is a rubber-ized shield, usually flipped down in operation but flipped up here to show the cutting nozzle. The flat material to be cut is secured on the bed slats, and in normal operation, the water level is raised to cover it, and the nozzle is set and moves just above the material. The water pool helps dissipate the energy of the jet as it cuts through. The thick tube feeds garnet into the nozzle from the hopper above.

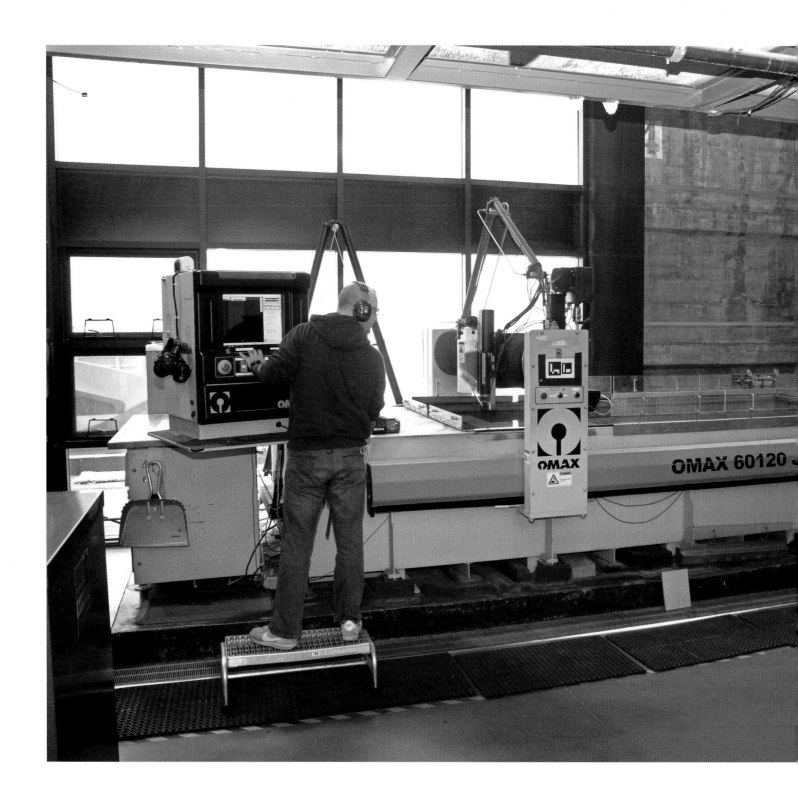

The waterjet is computer numerically controlled (CNC). Cut patterns and designs are converted into a language that the machine can understand and process into cutting directions. Users define the thickness and type of material to be cut, which changes the power and speed of the machine. For *Cut in Half* I used a saw function, and set variables to the closest approximation based on what I cut.

The waterjet is big: approximately 20 × 17 feet (6 × 5m), with a cutting pool of 13 × 10 feet (4 × 3m). I operate the machine standing on a small step, stationed at the computer controls and ready to hit an emergency stop button if something unexpected happens. There is a satellite set of controls on the gantry column to the right if you want to watch from closer to the cutting head. At the far right in the back is the pressurized yellow tank that holds the garnet and feeds it into the hopper. The black arm and slender silver tube above the gantry channels water from a high-pressure pump, which is in a cabinet near my legs.

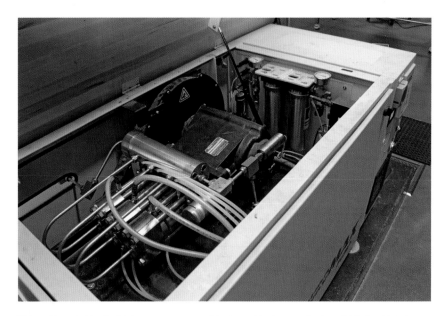

This cabinet holds the high-pressure pump (the large black mass in the middle), which draws water from the cutting bed pool into filters for cleaning, then pumps it back into the machine when cutting. It's capable of creating 60,000 psi of water pressure, monitored along with the filters through the two gauges seen on the far right of the cabinet. The slender steel hoses transfer the high-pressure water from the pump and into the cutting nozzle.

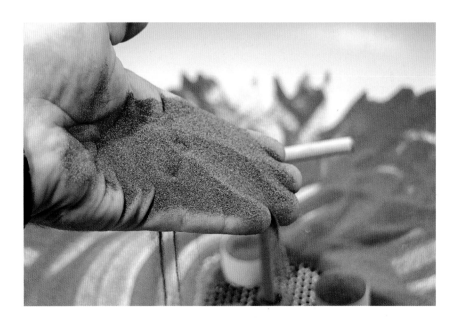

This fine reddish garnet sand is the material that does the actual cutting. There is a small opening in the side of the cutting nozzle that draws in the garnet as high-pressure water rushes past using the Bernoulli principle, shooting the waterborne garnet through the nozzle. You can think of waterjet cutting as a sort of focused erosion. Spent garnet sinks to the bottom of the pool and, unlike the water, is not reused.

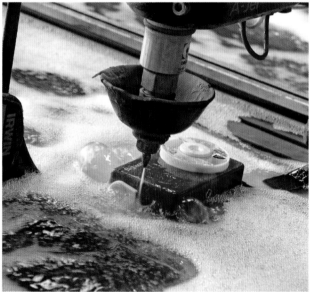
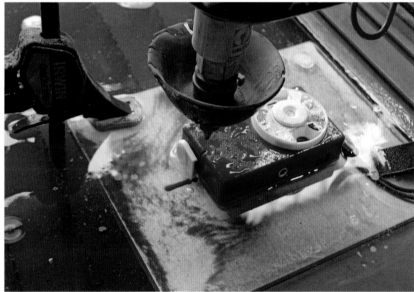

The waterjet is designed to cut large flat materials, such as sheets of steel and aluminum. For *Cut in Half*, I secured atypical items to be cut on scrap plywood so they didn't fall through the bed slats. The board is then clamped either to the clamping bar or with a quick-release clamp directly to the support slats.

The waterjet can make very small and precise cuts in sheet goods, and the work I put it to for *Cut in Half* doesn't always reflect the grace the machine is capable of. When cutting consumer goods, the waterjet often blasts through and tears loose smaller internal components, which can be lost in the water pool.

After each cut, I remove the item and gently clean it under running water to remove trapped garnet stuck inside. Any steel inside usually rusts within minutes—an effect you can see on the steel springs or clips in the photos that follow in this book. I pry the item off the sacrificial cutting board and inspect it, reassembling any shifted or scattered components, cleaning, and gluing everything back together as it should be.

HOUSEHOLD APPLIANCES

Heating Fan

There's beauty in the simplicity of this assembly. Cool air is drawn into the back of the fan by the rotating fan blades and passed over a heating coil. The heated air is then pushed out the front of the unit. The fan is powered by an electrical motor that spins the blades. The heat temperature and fan speed are controlled by two potentiometers, which are voltage restrictors that limit how much power the fan or heater receive. These controls are located at the bottom of the fan.

The safety warnings on these heating fans advise not to block either side of the fan, for good reason. Looking inside, we can see that if the cool air entrance is blocked, the heating element will not have fresh cooler air to heat, which can lead to overheating and potentially melt the plastic housing. More sophisticated fans sometimes have a thermostat that shuts off the heat if it gets too hot.

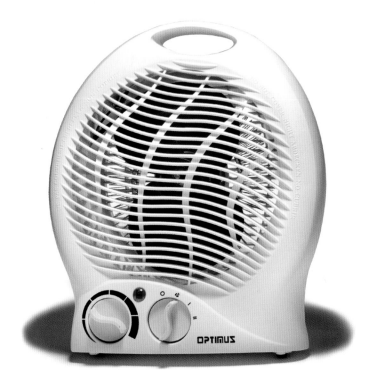

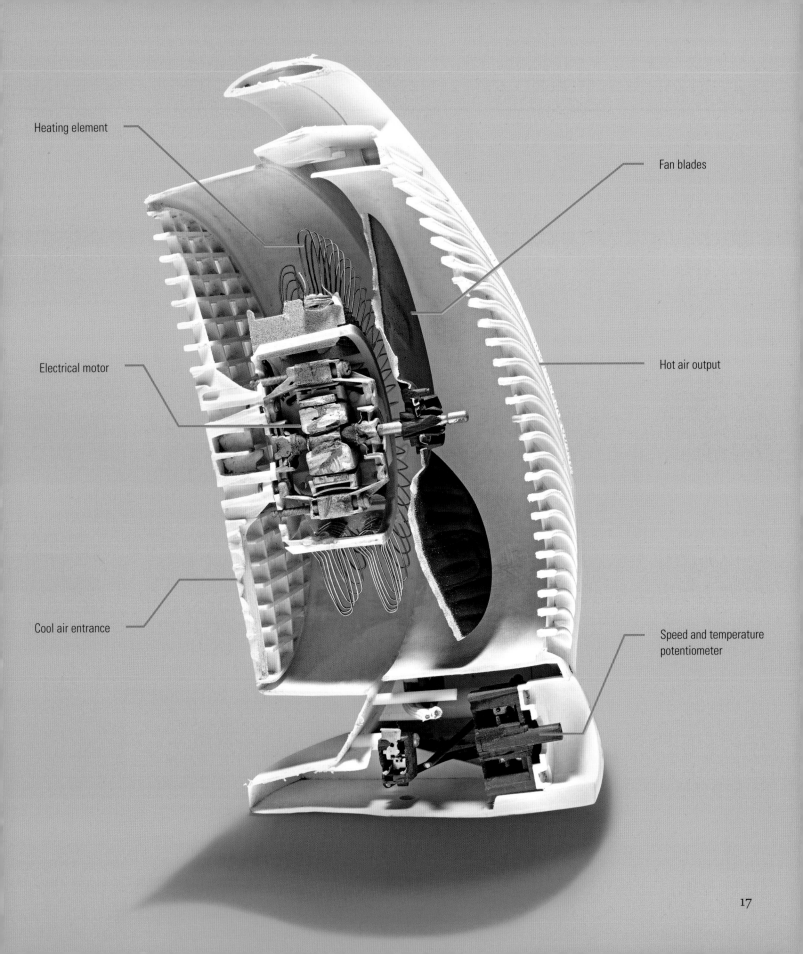

Heating element

Fan blades

Electrical motor

Hot air output

Cool air entrance

Speed and temperature
potentiometer

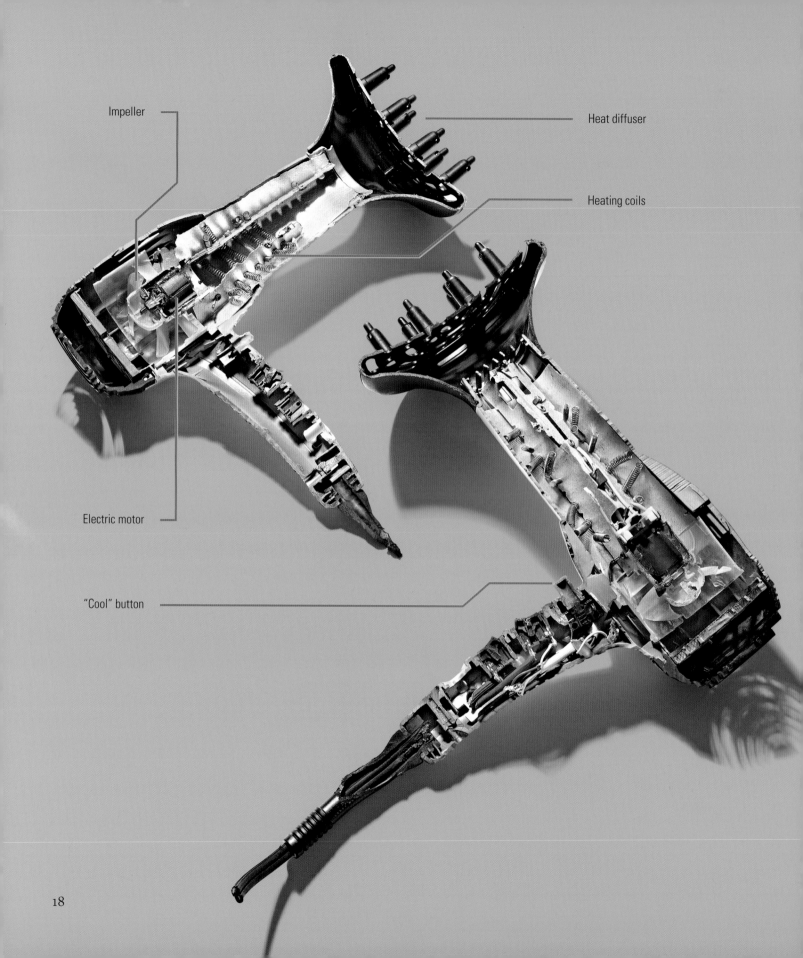

Impeller

Heat diffuser

Heating coils

Electric motor

"Cool" button

Hair Dryer

A small but high-powered electric motor spins an impeller (basically, a small fan) to draw air in from the back of the hair dryer. The air is pushed through the body of the device over a series of heating coils, which heat the air. The hot air is pushed out a nozzle and through a diffuser to spread the air.

In the handle of the dryer are controls that adjust its heat and speed. This model also includes a blue "cool" button, which does not actually chill the air, but instead stops the heating coils from energizing and allows a cooler mix of room temperature air to blow through the dryer.

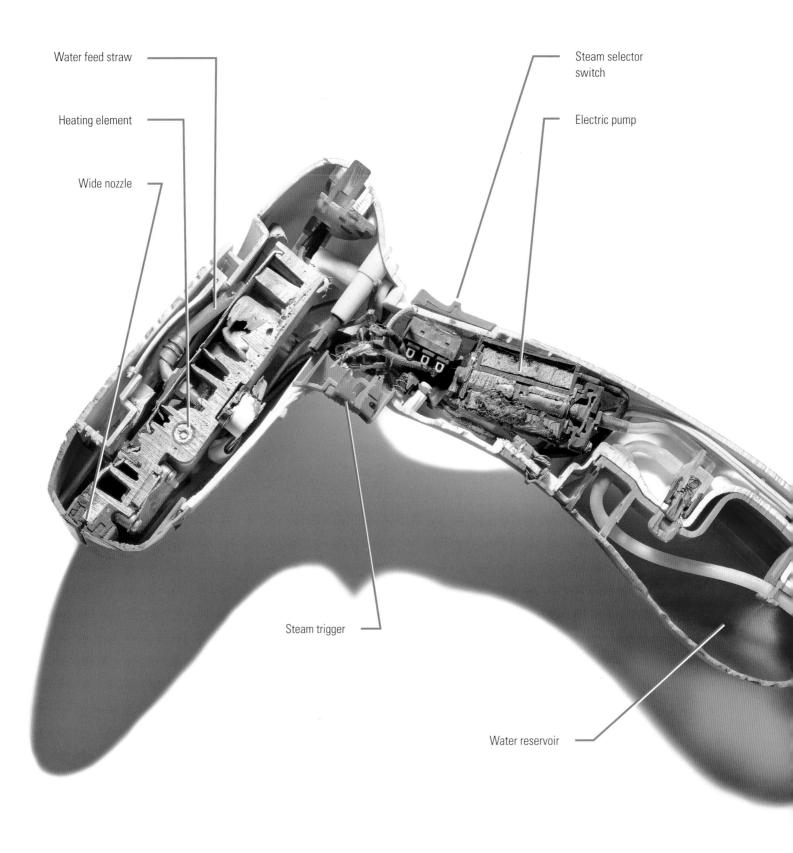

Water feed straw

Heating element

Wide nozzle

Steam selector switch

Electric pump

Steam trigger

Water reservoir

Clothing Steamer

A handheld steamer allows you to steam garments to remove wrinkles on items that may be awkward to handle on an ironing board, such as drapes and very delicate clothing. Much like a traditional clothing iron, this handheld steamer has an onboard water reservoir and a heating element that converts the water to steam.

An electric pump transports the water from the reservoir to the heating element. A straw feeds water from the bottom of the reservoir through the pump and onto the top of the heating element. The heating element turns this water into steam, which then escapes out the front wide nozzle of the steamer. A trigger on the handle activates the pump and starts the steaming process. A selector switch on the back of the handle controls how much water is pumped when the trigger is pressed.

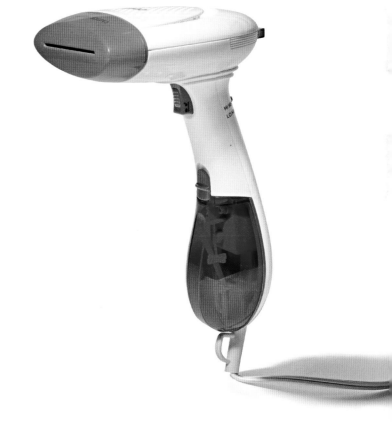

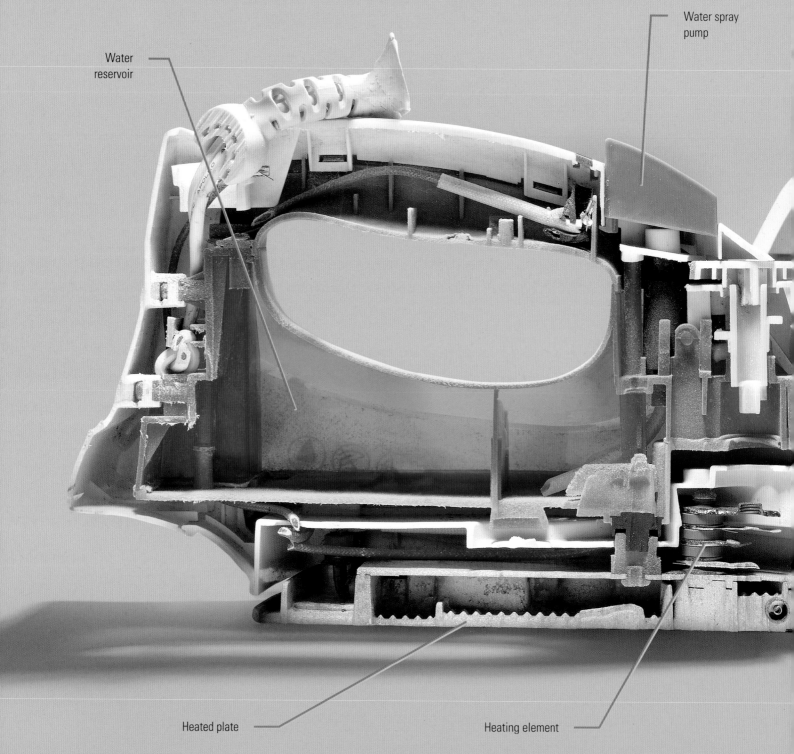

Water spray pump

Water reservoir

Heated plate

Heating element

Clothing Iron

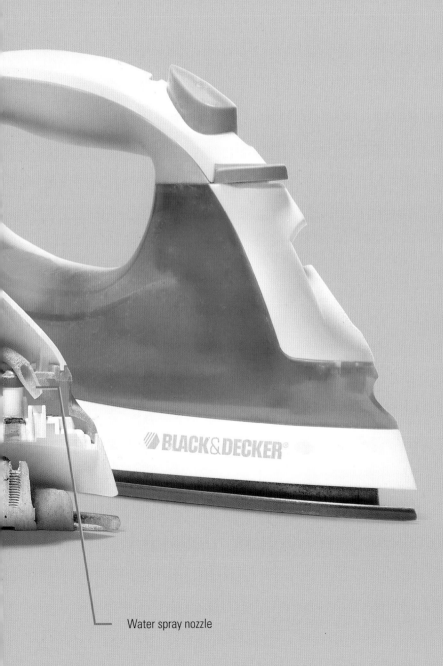

Water spray nozzle

The combination of heat and water creates steam. These elements, when applied to wrinkly clothes, remove kinks in the fabric and smooth the textile— perfect for looking sharp.

This clothing iron generates heat from an electric element made from coiled wire. The heat is then dispersed through a plate on the bottom of the iron. Water from an onboard reservoir is channeled to a spray nozzle at the front of the iron. After the water is sprayed, the heated iron travels over the garment to create steam to iron your clothes.

In this picture you can especially see the effects of abrasive material from the waterjet on the translucent plastic housing, in the frosty-looking middle of the inside of the iron. This can be caused by jet deflection, here through such a tall body made from nonhomogenous materials.

Cordless Drill

Cordless power drills such as this one use a battery pack that connects to the bottom of the handle. A keyless chuck allows drill bits and attachments to be inserted and easily tightened by hand, without the need for a special key to secure them. Modern cordless drills have a torque limiter, the numbered ring around the chuck, that controls the amount of torque applied when screwing to prevent a screw from being overtightened or cam out (when the blade jumps out of the screw and strips the screw head). This sophisticated technology can be seen as the mass of gray gearing behind the chuck.

This model uses a brushed motor, which we can see at the far back of the drill. The motor takes an electrical charge from the battery and passes it through carbon brushes and into the commutator, which transfers the energy to the armature, an iron core wrapped with copper windings. This magnetizes the core, which pushes against a stationary ring of magnets surrounding the armature and forces the armature assembly to spin. The charge to the brushes and armature is controlled by the drill trigger.

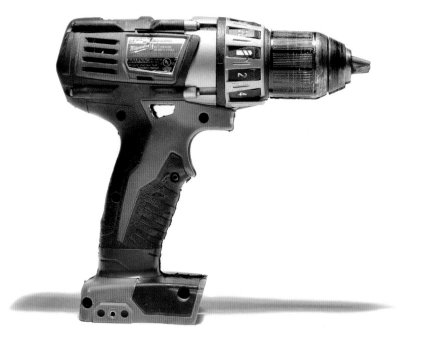

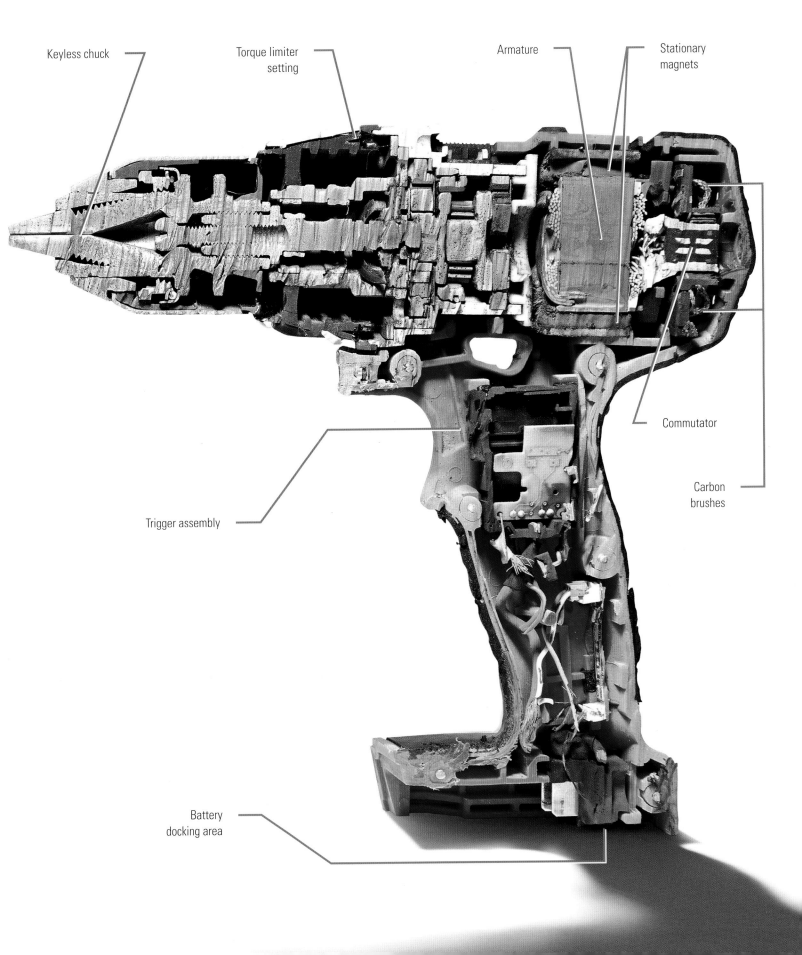

Keyless chuck

Torque limiter setting

Armature

Stationary magnets

Commutator

Carbon brushes

Trigger assembly

Battery docking area

Electric Kettle

Nothing satisfies quite like a steaming cup of tea, coffee, or hot chocolate. The electric kettle allows your favorite hot beverage to be made away from the stove in the kitchen and can be conveniently placed anywhere there's an electrical outlet.

There are a few different types of electric kettles on the market, including some (not this one) that use a heating coil that is immersed directly in the water. Instead, this kettle takes advantage of the fact that heat rises and employs a heating element under its floor, heating the water above. A long thermostat sensor tube carries steam from inside the kettle down to a thermostat in the base that switches the heating element off when the water is at a boil. The window near the handle shows the level of the water inside the kettle, and a fine mesh strainer near the spout captures loose tea leaves or other items you may have placed inside the kettle while it was boiling. The kettle's stainless steel body can durably withstand high temperatures and is easy to clean.

Thermostat
sensor tube

Spout

Water level window

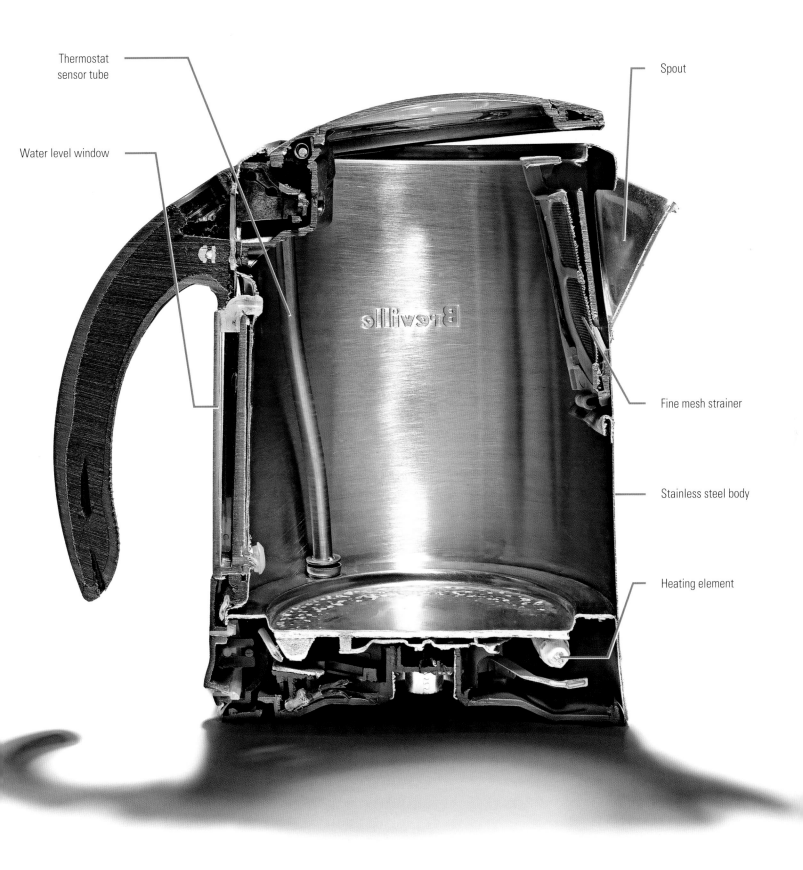

Fine mesh strainer

Stainless steel body

Heating element

Electric Popcorn Popper

A fun way to think of an electric popcorn popper is as a hair dryer pointing upward. Poppers and dryers both use an impeller to draw air in and blow it over a heating coil, powered by an electric motor.

This popcorn popper has a chamber to hold the corn kernels, which is then heated by the coil below. The impeller blows hot air into the chamber and heats the kernels until they explode, turning them into popcorn. The perforated grate in the bottom of the chamber allows the hot air to push the light popcorn up out of the chamber and into the chute, funneling them into an awaiting bowl.

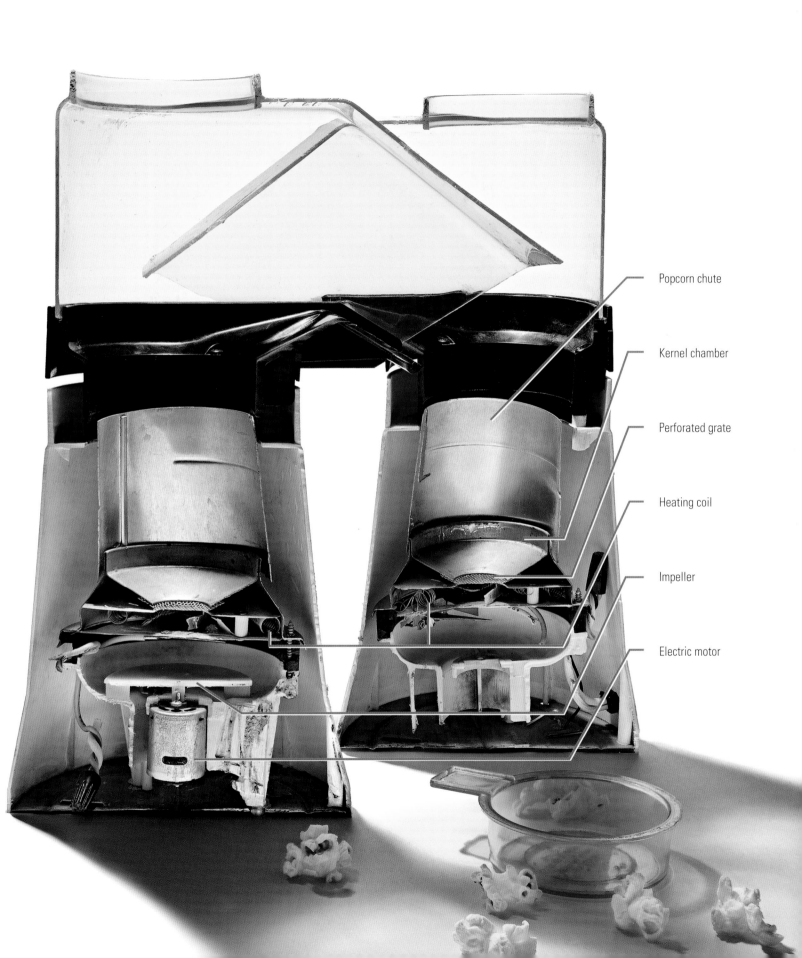

Popcorn chute

Kernel chamber

Perforated grate

Heating coil

Impeller

Electric motor

Waffle Iron

Waffle irons heat up dimpled metal plates to cook waffle batter into its iconic shape. All electric waffle irons take electrical energy and apply it as heat to the two plates in order to ensure uniform cooking and a tasty breakfast.

As with the other devices in this book that use heating elements, the temperature for this waffle iron is controlled by a potentiometer, which tells the unit how much heat energy to apply. The wires inside are coated with a heat-resistant jacket to prevent them from melting while the unit is in operation.

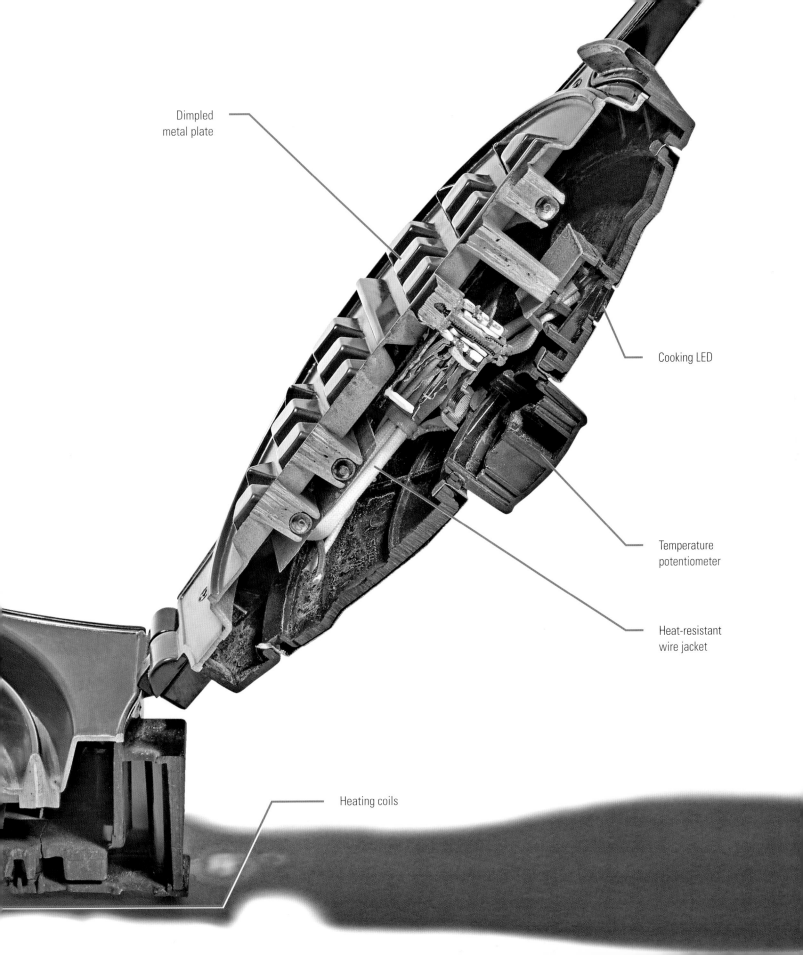

Dimpled
metal plate

Cooking LED

Temperature
potentiometer

Heat-resistant
wire jacket

Heating coils

Touch-Tone Telephone

These phones borrow their functional design from the rotary telephones of the 1960s, though they are more technologically advanced on the inside.

Instead of an analog rotary dial sending a signal through the telephone to dial the number, touch-tone phones employ push-buttons connected to a circuit board, which sends out sound tones to dial a number. The rest of the components inside are very similar to rotary phones: a bell for ringing when you receive a call, a mechanical hang-up pin, and a ceramic magnet speaker to hear the person on the other end of the line.

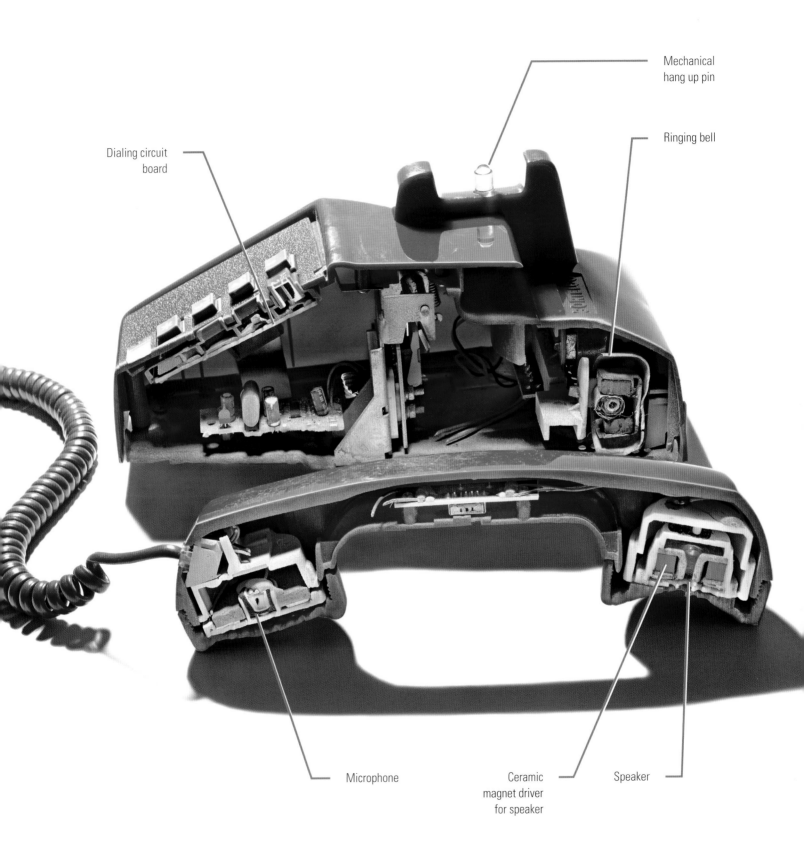

Mechanical
hang up pin

Ringing bell

Dialing circuit
board

Microphone

Ceramic
magnet driver
for speaker

Speaker

Telephone Handset

Though landline telephones have mostly been made obsolete by the ubiquity of cell phones, there was a time when every home had a few phones tethered to the walls by cords. The telephone shown here represents an era in technology when simple devices like this were made compact but not so far as to sacrifice the handheld legacy of phones that came before it, resulting in a large internal cavity around the circuit boards and speakers.

These telephones take information from the telephone line and process the signal in the circuit board, outputting a sound through the earpiece speaker. When you reply, a microphone in the mouthpiece transmits that signal to the circuit board, which then sends the information back through the phone line to the other end.

Most people don't realize that telephone wall jacks are powered. The telephone exchange has a battery bank that sends power through the phone lines and powers the landline phone. This power is used to drive the speaker you put to your ear and amplify the sound as well as illuminate the buttons on phones.

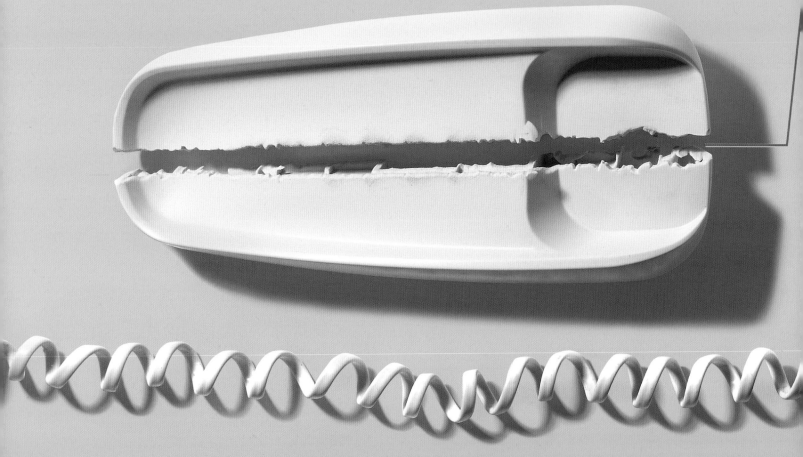

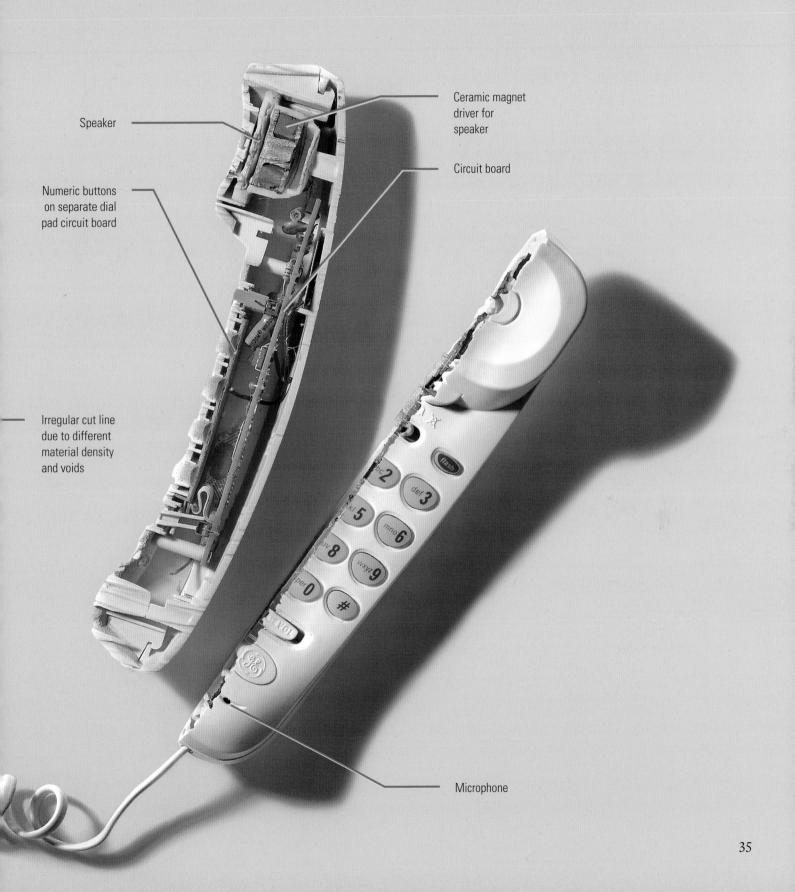

Speaker

Ceramic magnet
driver for
speaker

Circuit board

Numeric buttons
on separate dial
pad circuit board

Irregular cut line
due to different
material density
and voids

Microphone

Robotic Vacuum

This clever little robot navigates around your floor, changing course when it bumps into something while uncomplainingly vacuuming away. This semi-sentient robot uses a combination of sensors to know where it's going. A curved bumper in the front hosts a variety of sensors: a pressure sensor to detect when an obstacle is struck, wall sensors to tell the robot when it's about to make contact from the side, and cliff sensors to prevent the robot from falling down the stairs. Up top, an infrared sensor sends and receives signals to determine the size of the room and calculate how to best clean the area.

Inside, the device mainly consists of a large battery to allow for a lengthy run time and a container to hold the dust it has sucked up. This model has two sweeping brushes near the front to direct debris into the center of the unit and a large cylindrical brush to sweep debris into the vacuum path and into the onboard dust collection area.

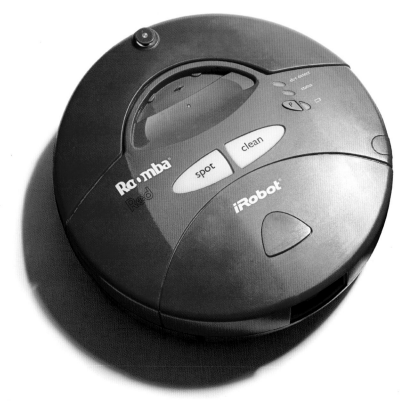

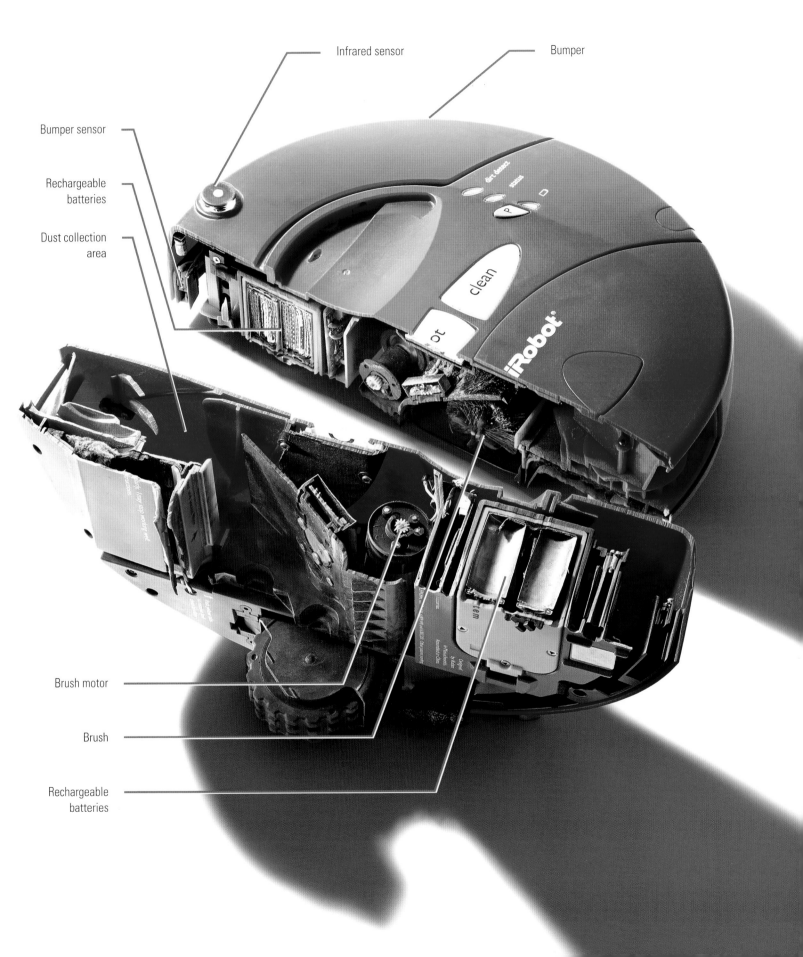

Infrared sensor

Bumper

Bumper sensor

Rechargeable batteries

Dust collection area

Brush motor

Brush

Rechargeable batteries

clean

iRobot

Handheld Vacuum

The handheld vacuum is an appliance I don't expect will ever be fully digital, no matter how much technology we throw at it. At its core, there will always have to be a motor that moves air through the machine to pick up dirt. The motor turns an impeller blade, which creates a vacuum inside the dirt chamber, allowing air to be sucked into the nozzle. As air is sucked into the vacuum, dust and debris are also carried into the chamber, where the air will continue into the impeller and out the exhaust while the dust is trapped by the filter and remains inside the dirt chamber.

Knowing how a vacuum works, and seeing inside this handheld model, you can appreciate how fast the impeller must turn to create enough of a vacuum to pull dirt off the ground and into the dirt chamber. This power is provided by the hefty battery array at the back of the machine.

Suction nozzle

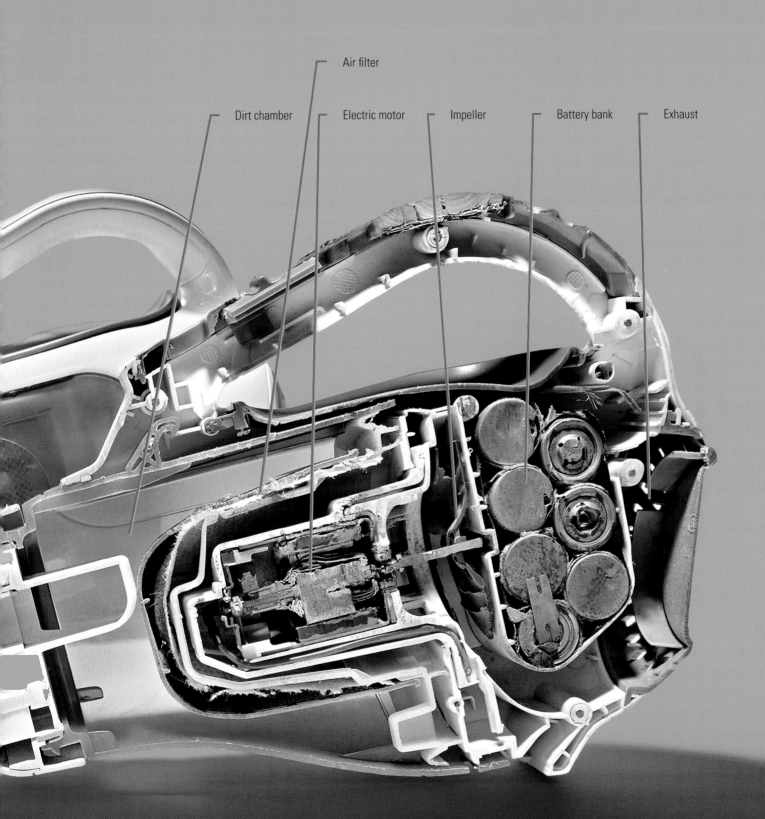

Dirt chamber

Air filter

Electric motor

Impeller

Battery bank

Exhaust

SPORTS EQUIPMENT

Bowling Ball

Bowling balls come in many different weights, and no two manufacturers make bowling balls in precisely the same way. In high-end professional bowling balls, the core is an asymmetrical mass that allows the ball to curve down the lane if a spin is applied as it is bowled. Balls produced for amateur bowlers are made more economically, generally with a solid core of vulcanized rubber or other dense medium. They are sealed with a durable polyurethane outer shell to withstand the constant impact bowling balls endure.

Inside this ball we can see small shreds of probably recycled cork mixed in with a hard vulcanized rubber. This strategy increases the volume of material filling the inside of the ball while reducing the quantity needed of more expensive rubberized material. As long as the mixture inside the ball is homogenous overall and meets the weight designation for the model, this is a good reuse for a material that might otherwise be destined for a landfill.

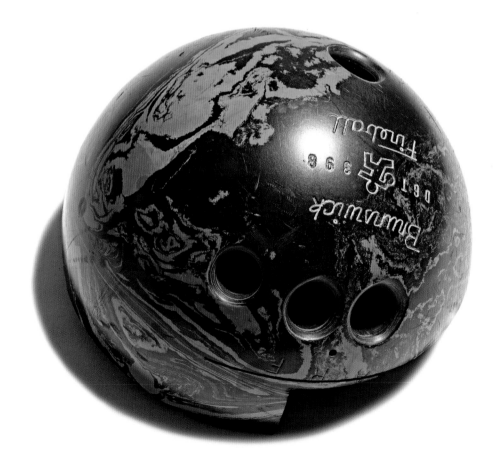

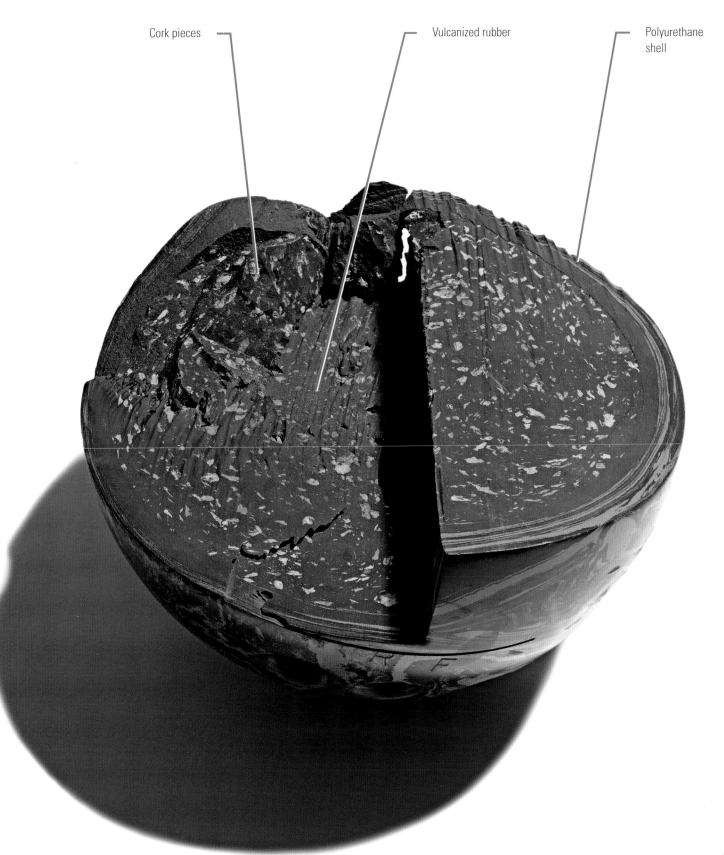

Cork pieces

Vulcanized rubber

Polyurethane shell

Bowling Pin

Not much thought is given to the humble bowling pin, mostly because it's so far away any time you see it. Regulation ten-pin bowling pins are made from gluing together blocks of maple hardwood, which are then turned to shape on a lathe.

The World Tenpin Bowling Association specifies that each pin must be manufactured at a specific height and circumference but allows for some variation in weight. A single pin must be at least 54 ounces and no more than 58 ounces (1.53 to 1.64kg). For a set of ten wood pins, the individual pin weights may vary by no more than 4 ounces (.11kg).

There are also regulations governing the weight distribution of the pin from top to bottom. Pins are allowed several voids in the belly area, which are needed to balance the narrower top half of the pin with the wider bottom half. These voids shift the weight distribution upward and prevent the pins from being excessively bottom heavy, allowing them to fall properly when struck. The pins are then coated in a durable plastic coating and painted with their iconic striped design.

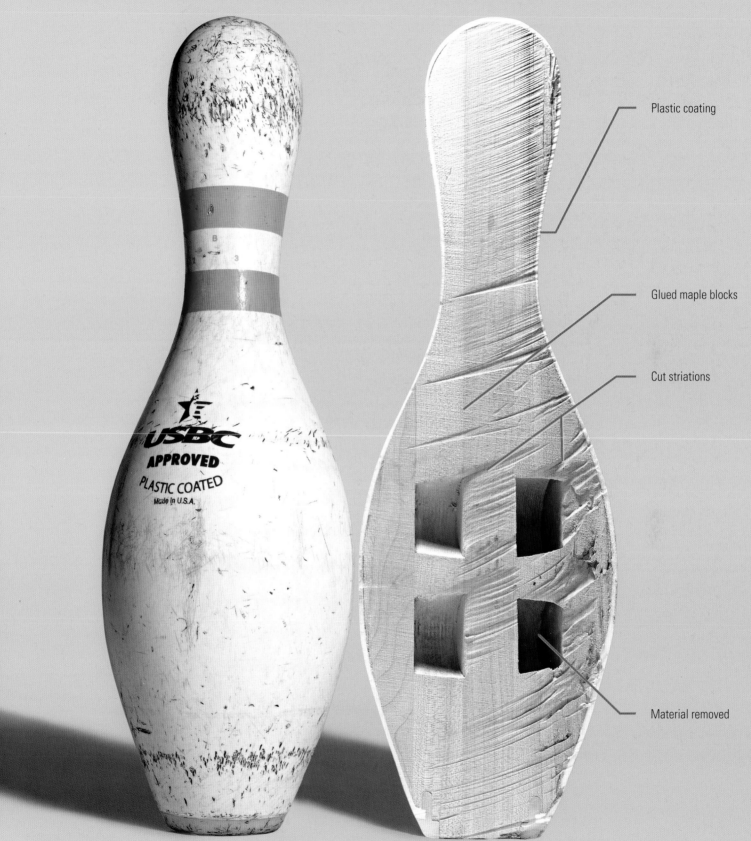

Plastic coating

Glued maple blocks

Cut striations

Material removed

Baseballs & Softballs

The game of baseball has a few different balls that are used, depending on what variation you are playing.

Softball uses a larger ball that's made of cork, covered in leather, and stitched closed.

Modern regulation baseballs are made up of a solid cork core, covered with black and then red rubber, and wrapped in a thick covering of wool yarn windings. The outer shell consists of thinner wool windings, which are then covered in white leather that's laced together with red stitching.

Practice baseballs are the same size as regulation baseballs, with a composite core wrapped in wool yarn, and synthetic material cover (synthetic covers are more durable than leather covers and retain their color over time).

There is also a very bouncy, soft compression baseball variation that's great for kids. The inside is made from a rubberized foam that allows the ball to travel farther than other balls when hit.

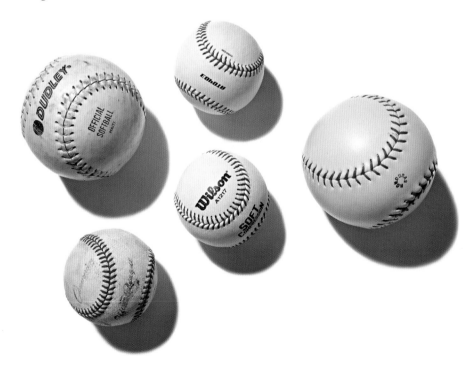

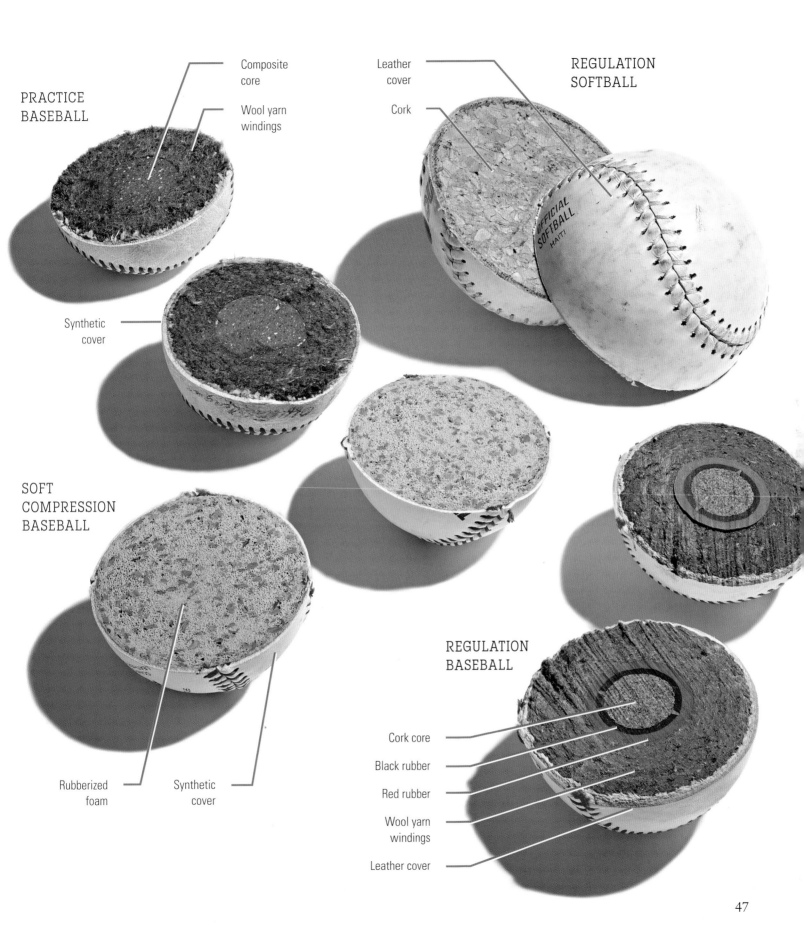

PRACTICE
BASEBALL

Composite
core

Wool yarn
windings

Synthetic
cover

Leather
cover

Cork

REGULATION
SOFTBALL

OFFICIAL
SOFTBALL
HAITI

SOFT
COMPRESSION
BASEBALL

Rubberized
foam

Synthetic
cover

REGULATION
BASEBALL

Cork core

Black rubber

Red rubber

Wool yarn
windings

Leather cover

Golf Balls

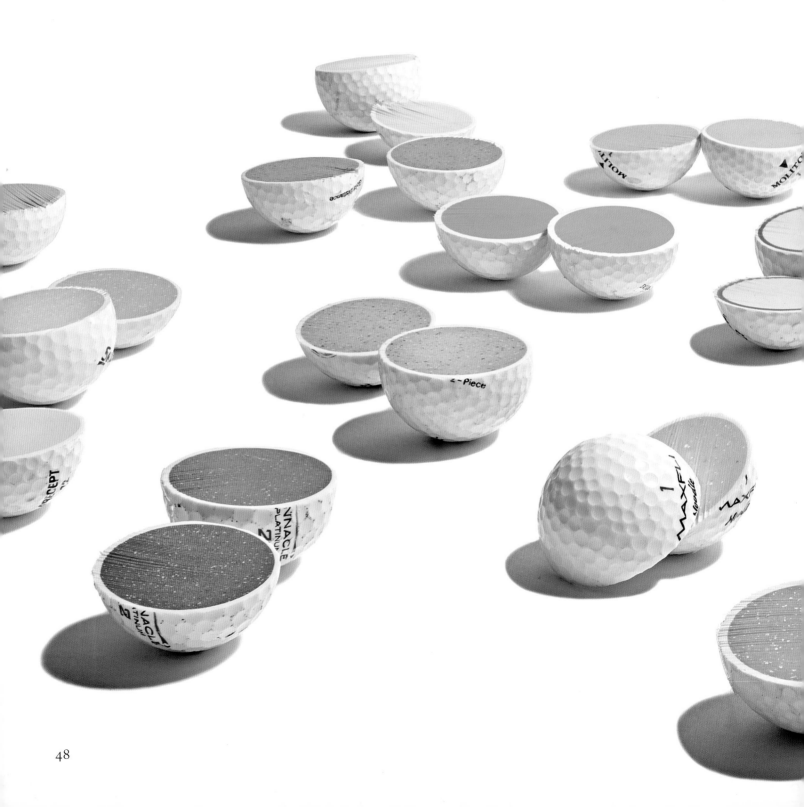

Athletes look to gain any edge over the competition, and so do sports equipment manufacturers. These golf balls all meet regulation requirements for size and weight but have different composites inside that the manufacturers believe gives a competitive advantage.

Each golf ball has a slightly different makeup of rubberized material inside, covered by a durable thermoplastic cover. The core for all modern golf balls is mostly rubber. Where they generally differ is if there is any filler material (the little flecks visible inside some of the cut balls), such as plastic or cork, designed to give the ball different dynamics when struck.

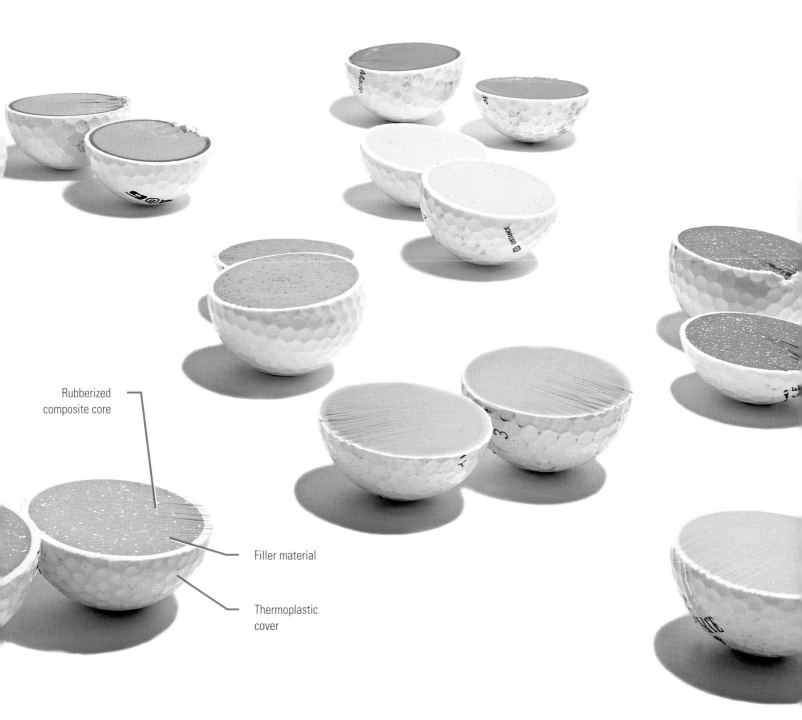

Rubberized composite core

Filler material

Thermoplastic cover

Golf Club Drivers

Manufacturers focus on different facets of a sport to push technology in new ways, helping improve an athlete's performance. For golf, the two main areas of technology for the athlete are the golf ball and the club.

Arguably the most important club in the game is the driver, as it sets up all future shots for a hole. A good drive can make successive strokes much easier, especially on challenging courses. Many golf

clubs are tailored to suit an athlete's playing style, like stance and height. While older golf drivers were made of solid wood, newer metal drivers are often aluminum or zinc, and are hollow. Some golf club manufacturers leave the cavity of the club hollow, while others fill it with a proprietary mixture that they allege enhances performance.

The club heads of these modern metal drivers are filled with foam: the lighter foam is more rigid, the darker more rubbery. The foam material is injected into the cavity near the end of the club fabrication process, then sealed shut as the foam expands to fill the cavity. The club shafts are usually made of hollow stainless steel or carbon fiber, which are flexible yet durable. The handle grips are rubber and feel much like bicycle handlebars.

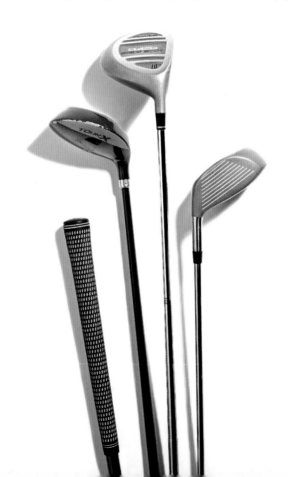

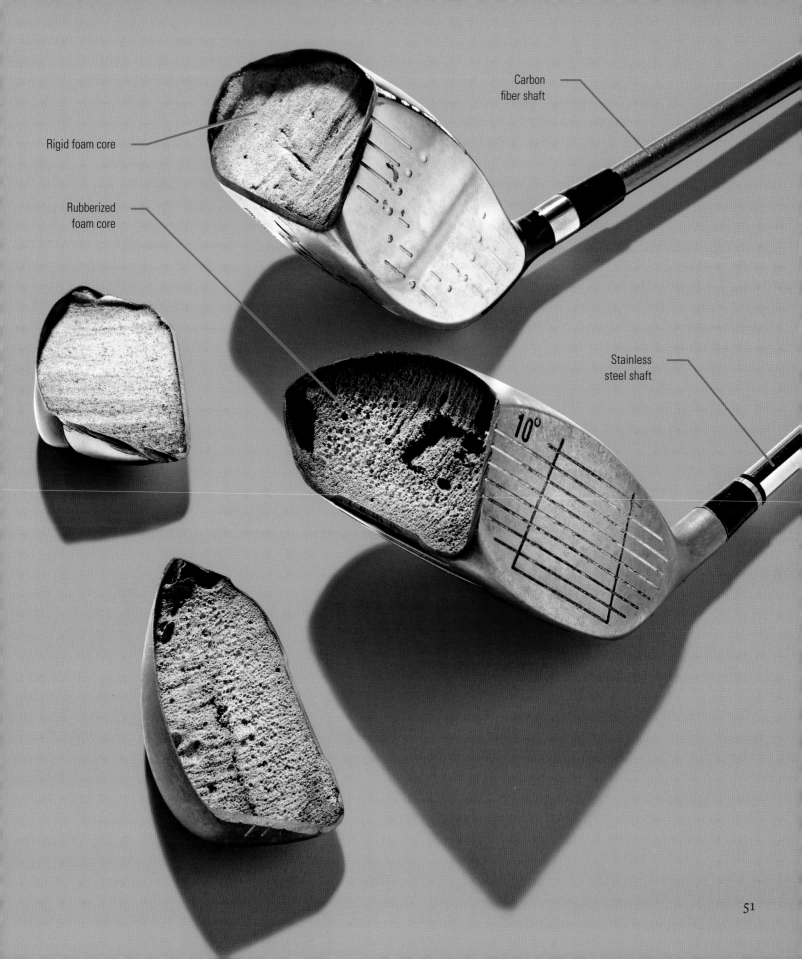

Rigid foam core

Rubberized foam core

Carbon fiber shaft

Stainless steel shaft

10°

Fishing Reel

The reel of a fishing rod keeps the fishing line neatly stored on a ratcheted spool. The spool is hand cranked to reel in the line and collect it on the spool. The ratchet allows the line to be drawn in, but prevents the line from going back out, pushing the ratcheting mechanism against the ratchet rack. The ratchet can be reversed for casting, to allow the spool to smoothly release as much line as needed for a long cast.

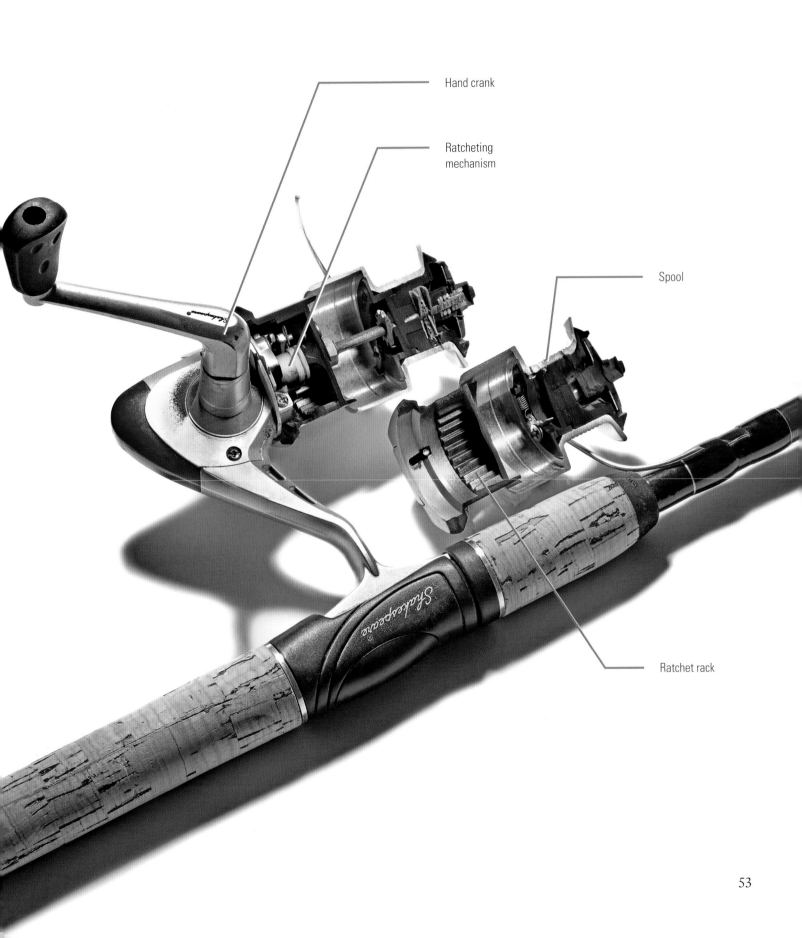

Hand crank

Ratcheting
mechanism

Spool

Ratchet rack

53

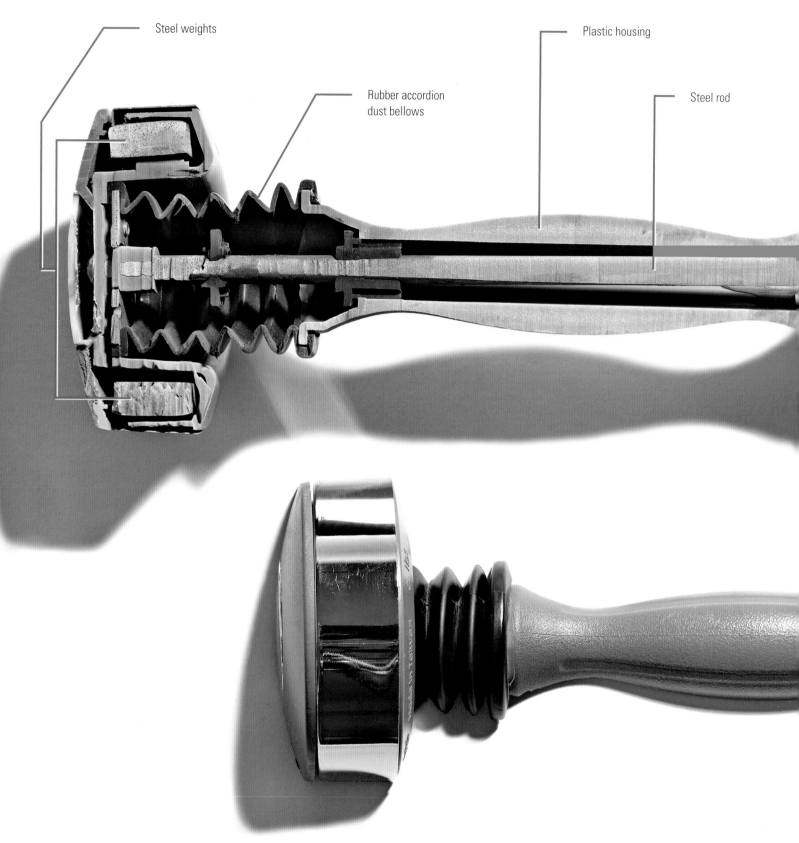

Steel weights

Rubber accordion
dust bellows

Plastic housing

Steel rod

Isometric Excercise Equipment

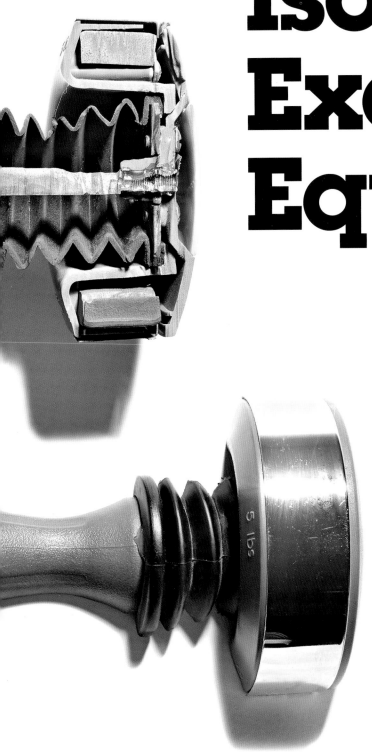

Isometric (as opposed to isotonic) exercise is defined as exertion against resistance and does not require a muscle to change length when exercised. This piece of equipment is held with two hands around the middle, with a weight on either end of a steel rod. When shaken, the resistance used to prevent the moving weight from slipping out of your hands is the exercise.

Inside we can see a steel rod attached to steel weights on either end that can slide independently of the plastic handle housing. Rubber accordion bellows connect the plastic handle to the steel weight assembly, keeping dust out of the sliding operation.

Sports Cleats

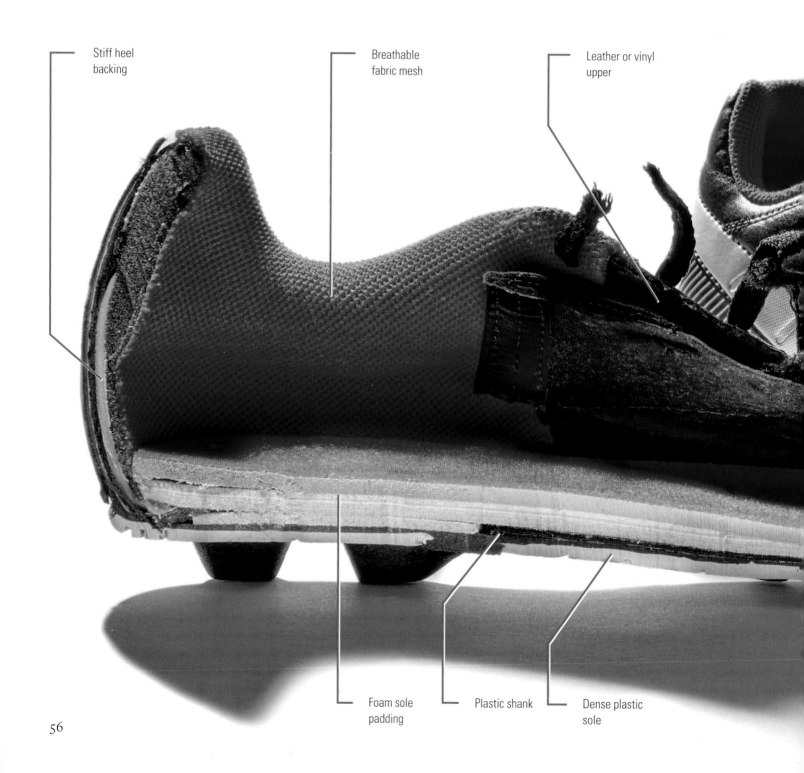

Stiff heel backing

Breathable fabric mesh

Leather or vinyl upper

Foam sole padding

Plastic shank

Dense plastic sole

Soccer (or football, depending on where you live) is a game of speed, requiring quick movements to kick the ball downfield and into the goal. As such, soccer shoes, called cleats, need to be durable yet lightweight. These soccer cleats have a strong plastic shank that runs down the underside of the shoes, giving them plenty of support, and stiff heel backings that allows the cleats to fit snugly around the player's foot once the shoe is laced tightly.

The cleat sole is made of a dense plastic, which stands up to abuse and protects the player's feet from wet field conditions. The insides of the cleats close to the feet are more forgiving than the hard outer soles and back, featuring breathable fabric mesh and foam sole padding to cushion the player's weight. The uppers, which cover the toes, top, and sides of the foot, are generally made of leather or vinyl.

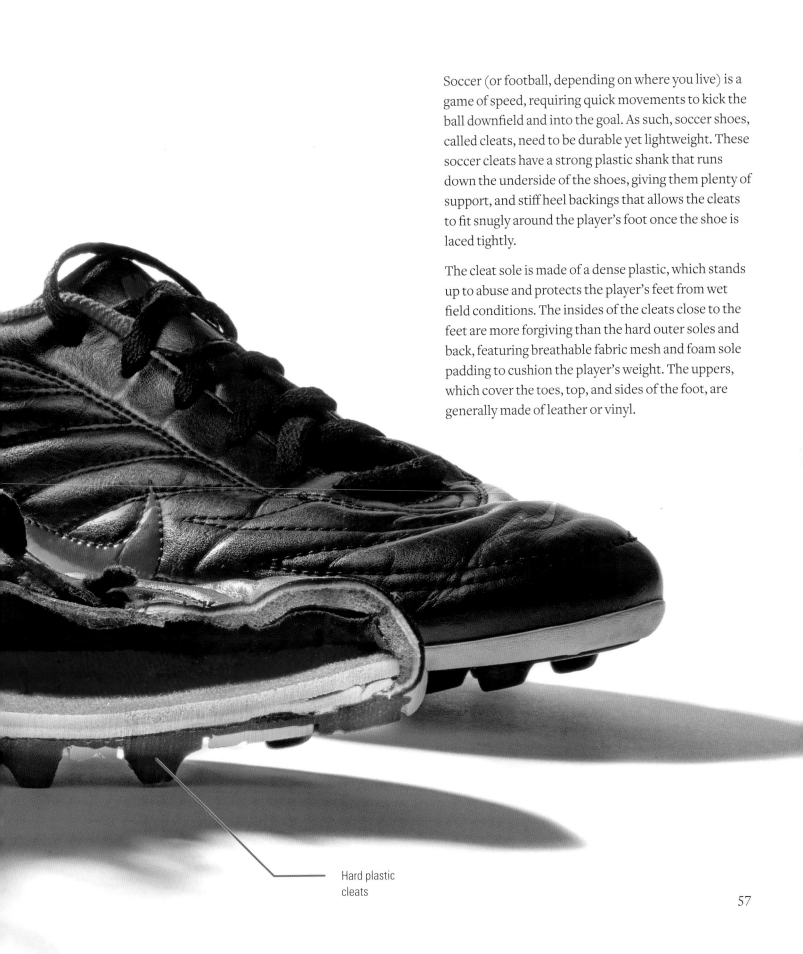

Hard plastic cleats

Boxing Gloves

Boxing gloves pack a punch. To keep boxers' hands protected round after round, layers of padding are laminated to dissipate the impact of a punch. The outermost layer is a thin moisture-resistant material, typically vinyl or leather, which keeps sweat from seeping into the gloves and into the padding. Below, a layer of light foam keeps the top of the glove soft for whatever target it hits, followed by a thick layer of dense foam to take the brunt of the impact. Under the dense foam is a very thin but much denser foam that protects the knuckles from the impact and dissipates the punch's energy as it reaches the boxer's hand. The inside of the glove is a tough cotton blend, making the gloves comfortable to wear.

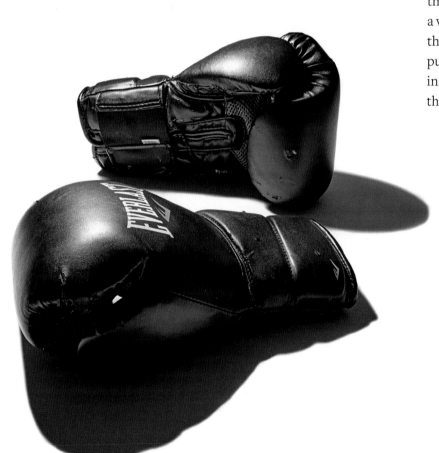

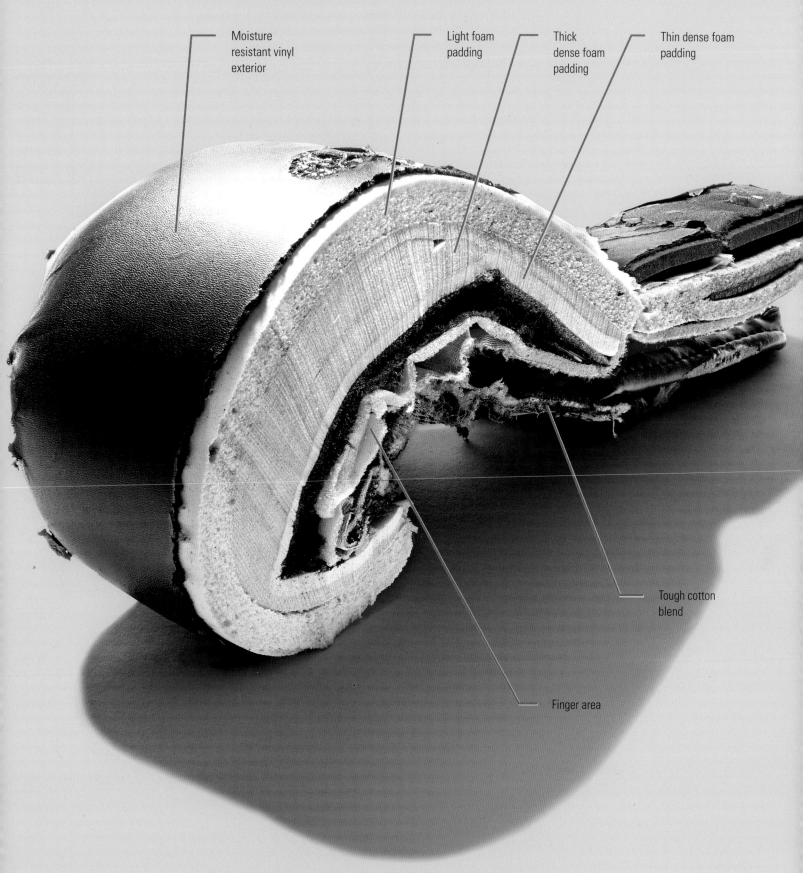

Moisture resistant vinyl exterior

Light foam padding

Thick dense foam padding

Thin dense foam padding

Tough cotton blend

Finger area

ELECTRONICS

Digital Camera

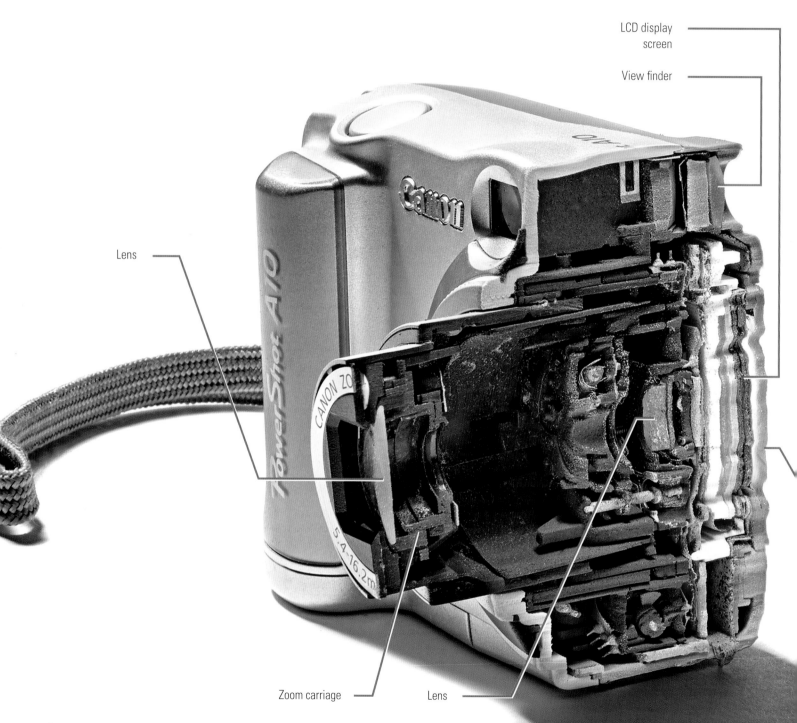

LCD display screen

View finder

Lens

Zoom carriage

Lens

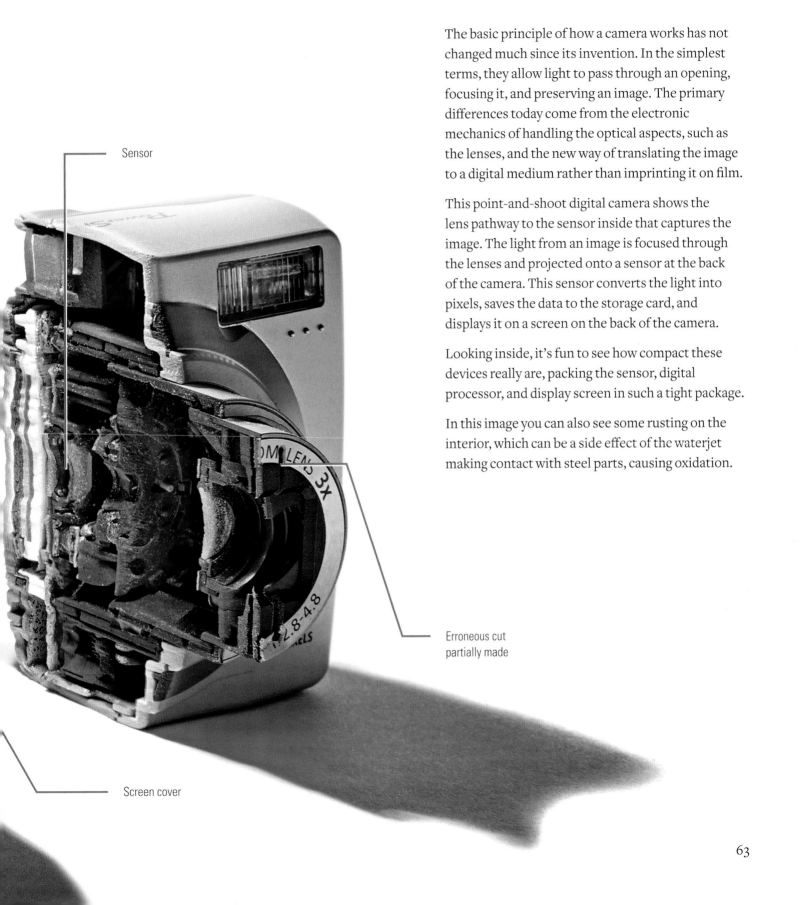

Sensor

Erroneous cut
partially made

Screen cover

The basic principle of how a camera works has not changed much since its invention. In the simplest terms, they allow light to pass through an opening, focusing it, and preserving an image. The primary differences today come from the electronic mechanics of handling the optical aspects, such as the lenses, and the new way of translating the image to a digital medium rather than imprinting it on film.

This point-and-shoot digital camera shows the lens pathway to the sensor inside that captures the image. The light from an image is focused through the lenses and projected onto a sensor at the back of the camera. This sensor converts the light into pixels, saves the data to the storage card, and displays it on a screen on the back of the camera.

Looking inside, it's fun to see how compact these devices really are, packing the sensor, digital processor, and display screen in such a tight package.

In this image you can also see some rusting on the interior, which can be a side effect of the waterjet making contact with steel parts, causing oxidation.

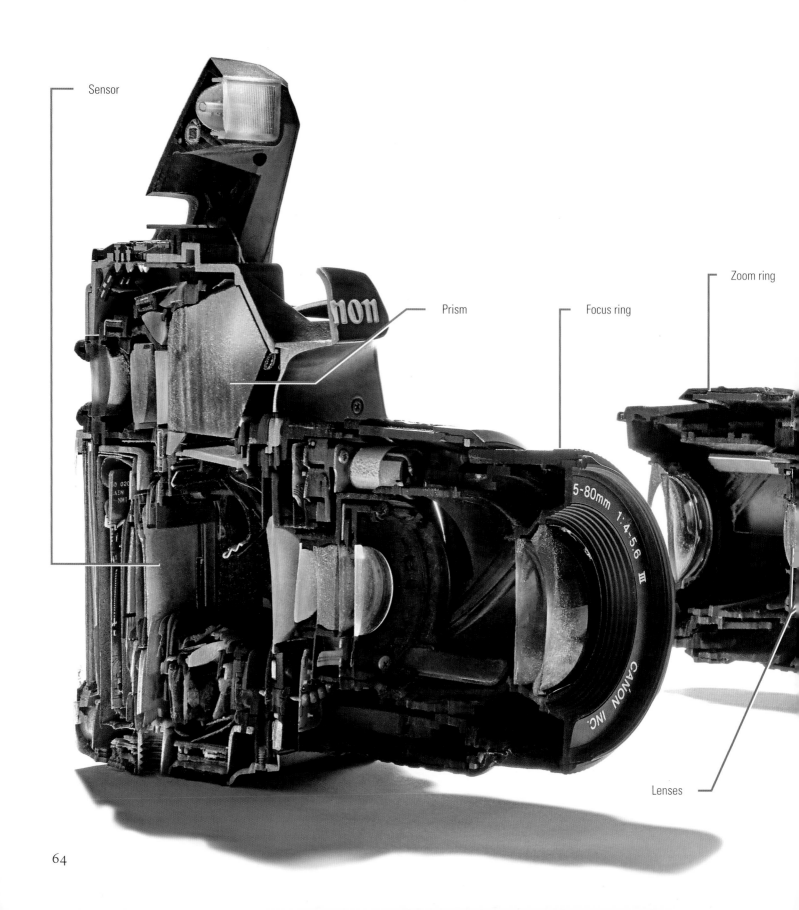

Sensor

Prism

Focus ring

Zoom ring

5-80mm 1:4-5.6 III

CANON INC.

Lenses

64

DSLR Camera

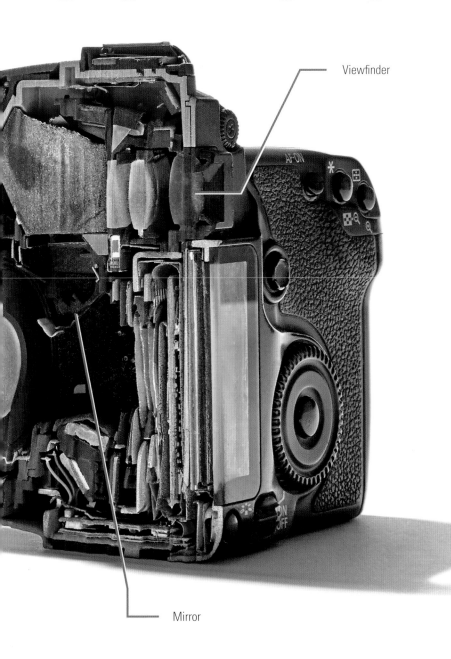

Viewfinder

Mirror

DSLR (digital single-lens reflex) cameras are just an updated version of the first cameras, which used a cover over an exposure plate to capture an image. Instead of an exposure plate, the DSLR uses a large digital sensor to capture the light information of the image, and produces a picture saved to a memory card. The sensor is completely covered by a small mirror that reflects the light from the lens upward, toward a prism that shapes the image into the eyepiece. When the shutter is pressed, the mirror moves out of the way, exposes the sensor to the light from the lens, and captures the picture. All this happens in a split second, but you can hear the action every time the shutter is pressed.

The large lens assembly focuses light into the camera. The lenses can be adjusted to magnify the image and shift the focal point, operated by the zoom and focus rings on the camera lens.

LED Light Bulb

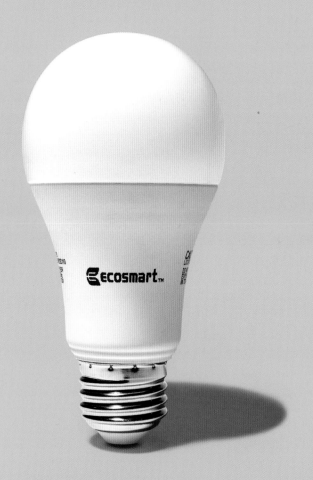

Even the ubiquitous light bulb reveals secrets when we look inside. Unlike traditional incandescent light bulbs that heat a thin magnesium filament inside a vacuum to generate light, this modern bulb uses light emitting diodes (LEDs).

This LED bulb has a ring of lights covered by a plastic dome that diffuses the light to an even glow. The power to the LEDs is controlled by a circuit board and electrical components hidden inside the body of the bulb. Not only are these types of bulbs more energy efficient, but they also outlast incandescent bulbs as there are fewer parts that wear out (for instance, no thin filament as in an incandescent bulb). As an added layer of durability, the empty space inside the bulb body is filled with a resin, which solidifies and protects the components from movement. This, combined with the plastic dome cover, means that this bulb could be dropped without causing any damage. How neat is that?

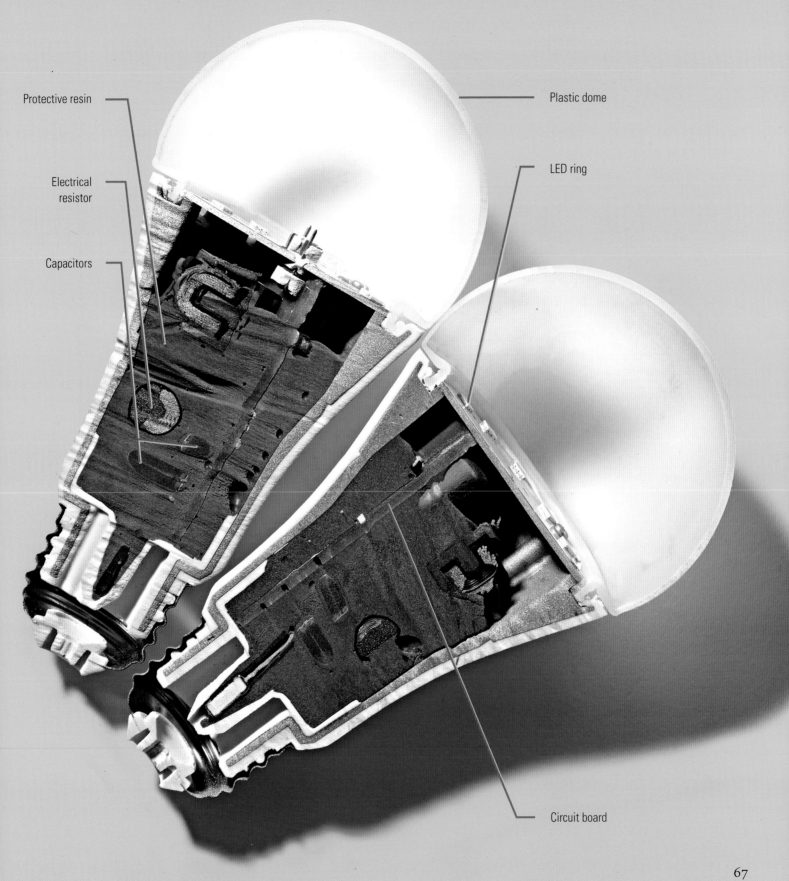

Protective resin

Electrical resistor

Capacitors

Plastic dome

LED ring

Circuit board

Electric Massager

These massagers use an electric motor with an off-center weight on the motor shaft to create an eccentric movement inside the device. This movement translates to a vibrating motion that can be applied to your muscles to relieve tension.

The battery compartment on the top has foam padding to help keep the batteries in place and prevent them from rattling around when vibrating. The top half is separated from the bottom with a silicone gasket, to isolate the vibrations to the lower half from the hand grip up top, insulating your hands from vibration fatigue.

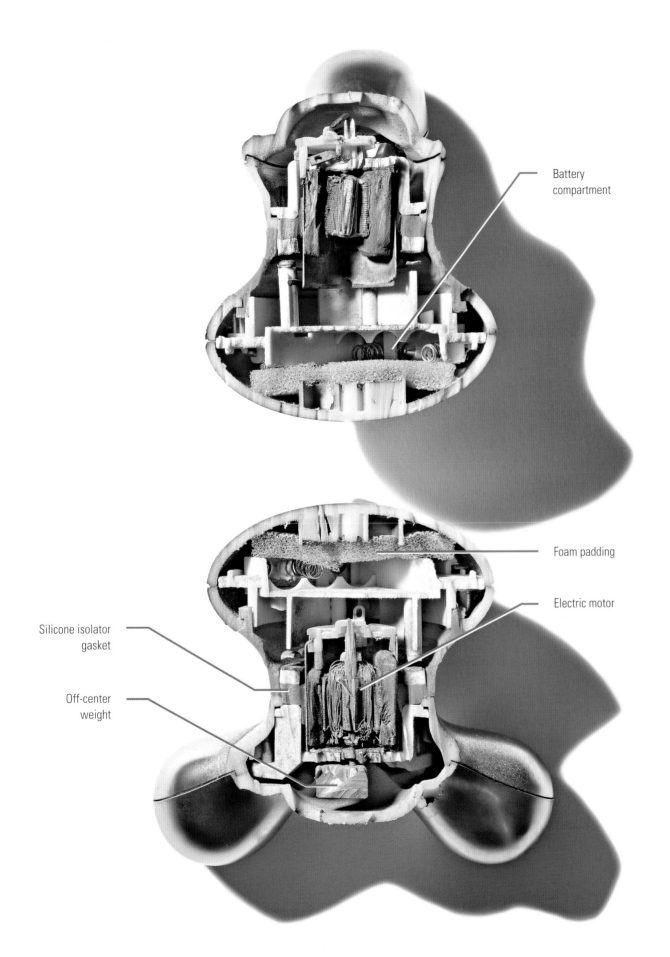

Battery
compartment

Foam padding

Electric motor

Silicone isolator
gasket

Off-center
weight

Audio Cassette Recorder

Once upon a time (in the 1960s), cassette tapes were an exciting innovation in portable recorded sound technology. Cassettes consist of a ribbon of tape running between two reels and encoded with magnetized information, allowing audio to be recorded and played back. While vinyl records were made in a factory and could only be played, cassette tapes were sold either containing pre-recorded content or as a recordable blank cassette, allowing audio to be recorded at home, a revolutionary (and contentious) development at the time.

Once a cassette tape is loaded into the machine, a magnetic device called the head is pushed against the tape ribbon. Much like a record stylus reads grooves on a record to create sound, the sensitive cassette head reads the tape for variations of the magnetic pattern, translating the information on tape into sound. A motor turns the reels to advance the ribbon.

I always find it interesting to look inside older electronics like this because they use analog mechanisms such as plastic gears and pulleys with rubber belts to move the components, very different than our digital devices today, which contain almost no moving parts.

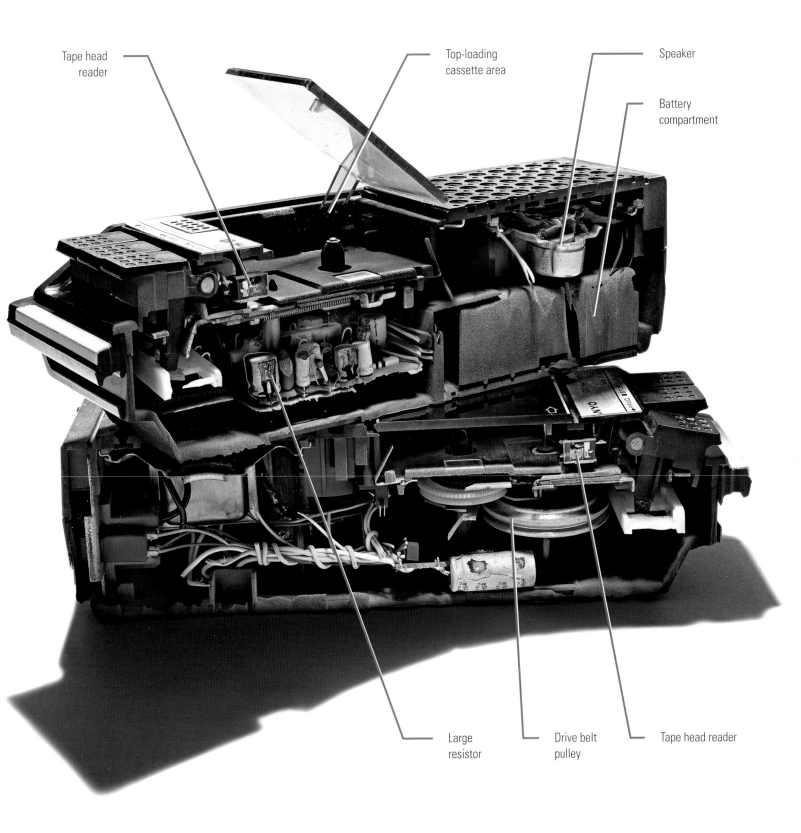

Tape head reader

Top-loading cassette area

Speaker

Battery compartment

Large resistor

Drive belt pulley

Tape head reader

Video Cassette Recorder

The video cassette recorder (VCR) is the video sibling of the audio cassette recorder. It uses almost the same basic technology of a magnetized ribbon between two reels that is read by a head inside the machine, except instead of just audio playback, the encoded information readable by the VCR includes both audio and video output.

The cassettes that the VCR reads are much larger than the compact audio cassettes and feature a flap on one end of them to protect the larger, more vulnerable ribbon inside. Video cassettes are inserted into the front of the machine, which then lifts the flap of the cassette and pushes the head against the magnetic tape to play the contents. This VCR uses mechanical systems to conduct the complicated movements inside, relying on gears, belts, and levers to lift the flap that protects the tape, stretch the tape over the video reading head, and advance the tape from reel to reel.

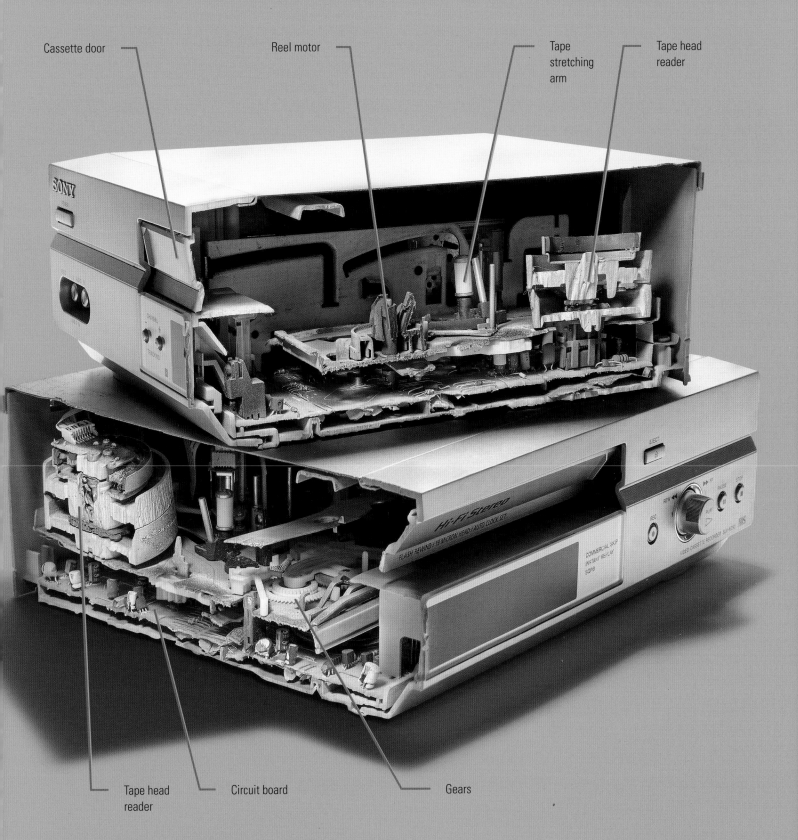

Cassette door

Reel motor

Tape stretching arm

Tape head reader

Tape head reader

Circuit board

Gears

Two-Way Radios

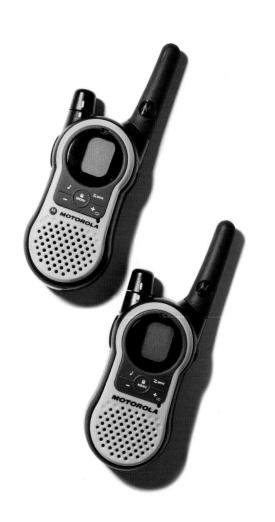

Walkie-talkies are two-way radios, allowing the operator direct communication with a recipient, who can also reply. Like many modern electronic devices, these walkie-talkies have been refined and modernized to be digital and use almost no moving parts. These radios use specific frequencies to make a connection with another device and not get the signal crossed with another user. The operator can switch frequency channels by rotating a channel knob on the top of the device. One of the many advantages of digital devices is the ability to have a digital readout, like a small screen; in the case of this model it's a liquid crystal display (LCD) screen.

Inside these walkie-talkies, the majority of the space is occupied by the battery, with the remainder of the space used for the LCD, the circuit board, and the few simple electronic components that allow all the pieces to work together.

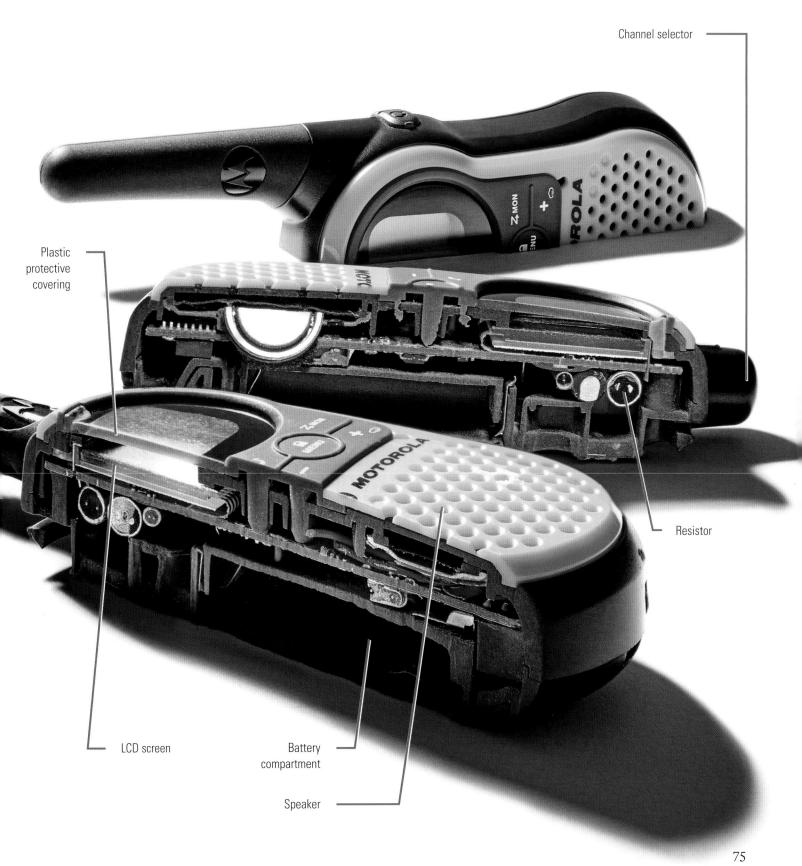

Channel selector

Plastic
protective
covering

Resistor

LCD screen

Battery
compartment

Speaker

MOTOROLA

75

PC Graphics Card

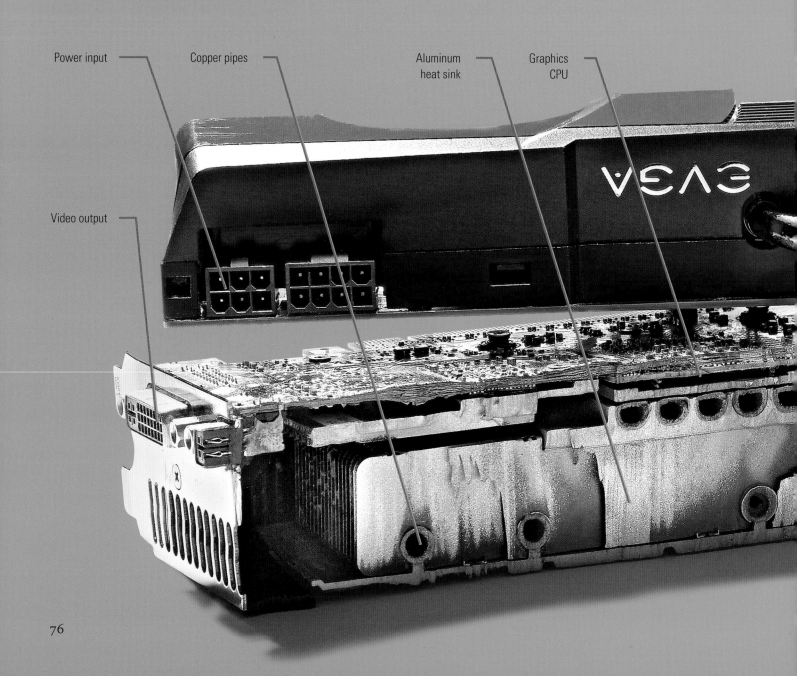

Power input

Copper pipes

Aluminum heat sink

Graphics CPU

Video output

Modern desktop computers have a dedicated graphics card that handles the intensive video operations required to run simulation software and video games. Instead of creating a bottleneck for the motherboard central processing unit (CPU), video data is diverted to the graphics card, allowing the CPU to handle the logic operations of the program.

The operation of these graphics cards generate heat, and so they require some method of cooling. This model uses both an onboard fan and a cooling system consisting of a large aluminum heat sink with copper pipes to create a circulating convection current of air. Copper and aluminum are chosen for heat sink applications as they are excellent conductors, allowing heat to be drawn away from the hottest part of the video card to be dissipated in air. The copper pipes shown in this card have a silvery coating to prevent discoloration (as copper dulls over time as it oxidizes) and for aesthetics.

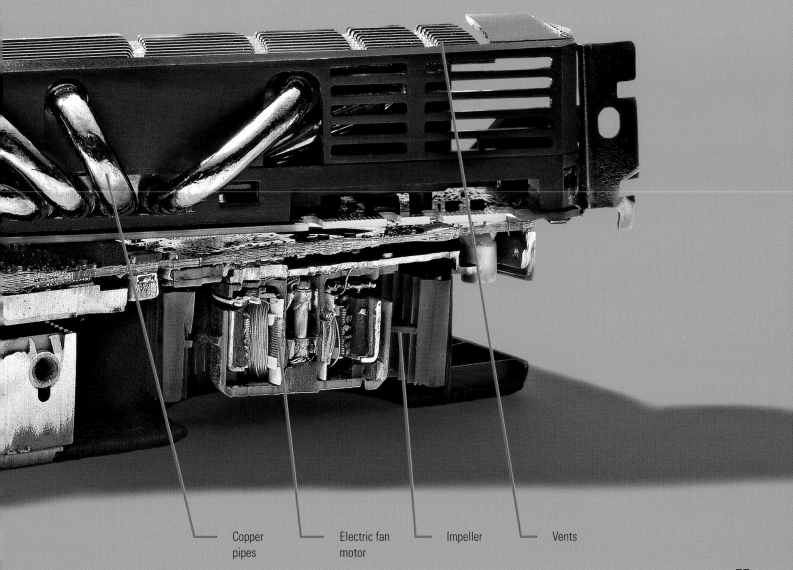

Copper pipes

Electric fan motor

Impeller

Vents

Video Streaming Device

These small devices take a signal from an Ethernet line, a cable that connects it to the Internet, and communicates with a service provider to digitally stream media to be displayed on a monitor or TV screen. The image data is conveyed from the streaming device to the display through an HDMI cable (High Definition Multimedia Interface).

The CPU (central processing unit) is in the center of the unit, with large aluminum heat sinks on either side to draw heat away from the device's core when operating. The CPU is responsible for digitally talking to the service provider and making the request for the user input, in this case a TV show or movie. The CPU then translates the information from the service provider and sends the signal to the HDMI output.

Cut striations

CPU

HDMI output
port

Aluminum
heat sink

HDMI output
port

Power input

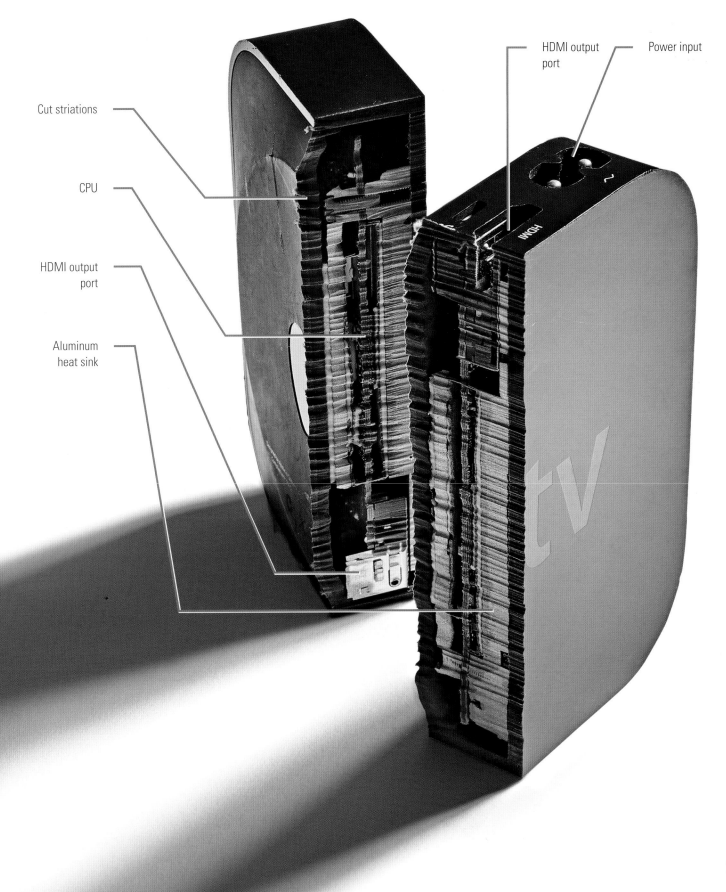

Laptop Computer

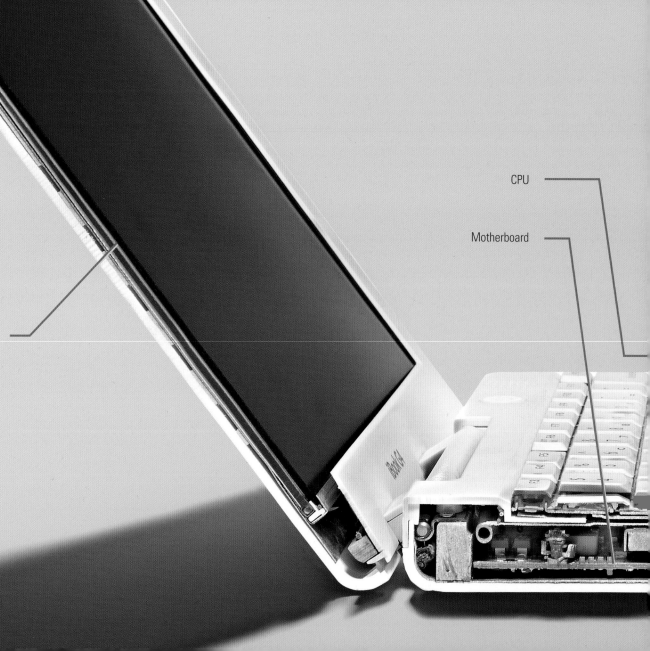

CPU

Motherboard

LCD screen

As technology progresses, electronic components get smaller, thinner, and faster. This older laptop is representative of what such computers looked like about fifteen years ago. The most notable differences are the large heat-sink for the central processing unit (CPU) on the motherboard, and the presence of a hard disk drive (HDD). These drives use spinning platters to store data, the platters themselves are made of aluminum coated with a highly reflective film of magnetic oxide. A drive head driven by a magnet passes over the spinning platter and can read and write data. Newer computers have solid state drive (SSD), which have no moving parts and are much faster at transferring information.

The laptop screen is a dense lamination of layers that each perform a specific function. Starting from the back of the screen, there is a backlight assembly that produces a white illumination, which passes through a few layers of diffusion screen to create a uniform light source. The next section of the screen is the LCD matrix, the electronic mesh that creates microscopic pixels of red, green, and blue. Millions of these small pixels densely packed together form images that we see on the screen. The last layers are the polarizing screen and anti-reflective coating.

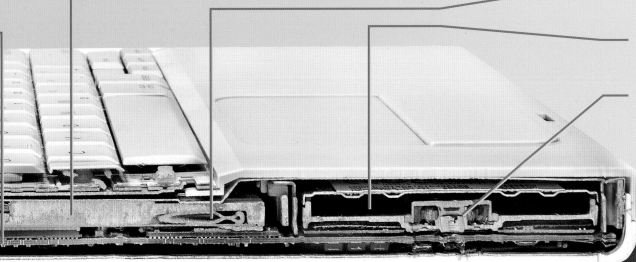

Aluminum heat sink

Copper cooling coil

Hard disk drive

HDD platter motor

Powered Speakers

These speakers use electrical power to amplify an audio signal, allowing a much louder sound than unpowered speakers. Power comes into the back of the speaker unit and into a transformer, which steps down the voltage from the wall socket to something lower that the circuitry inside the speaker can handle without overloading. The transformer itself is made of two separate wire windings set in an iron core.

The circuit board on these speakers is connected to the sound equalizer knobs located on the back of the unit. An equalizer allows the sound of the output to change depending on the desired effect, such as deeper base or higher mid-range. There are two speakers in each speaker box, a larger one for low notes and a smaller one for higher notes.

The circular port hole cut into the enclosure enables sound from the back of the speaker box to increase the efficiency of the low frequencies generated by the large speaker. The location of the opening is carefully chosen by the manufacturer based on the relationship of the driver size (speakers), the volume of the enclosure, and the tube cross-section length.

The shell of the speaker box is made from MDF (medium-density fiberboard), a dense wood product that isolates the waves inside the box and creates a fuller sound. The foam insulation serves the same purpose.

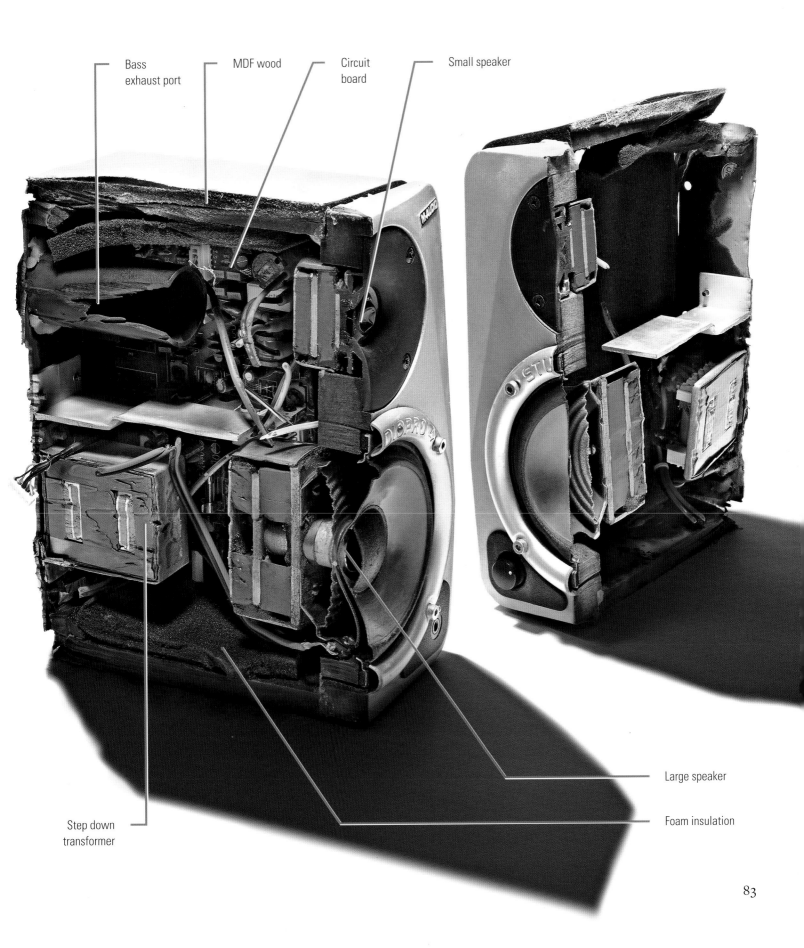

Bass exhaust port

MDF wood

Circuit board

Small speaker

Step down transformer

Foam insulation

Large speaker

83

Wireless Headphones

These Bluetooth headphones have an onboard power supply that allow for a tether-free listening experience, and buttons on the side, which allow control of music without the need to access a music player. A small control board sends signals over Bluetooth to your music player and can pause and change the songs being played.

On-ear headphones have foam padding to provide cushioning while being worn, as well as keep the speakers from resting directly on the ears. A small speaker on each side of the headphones uses the onboard power supply to amplify the sound signal.

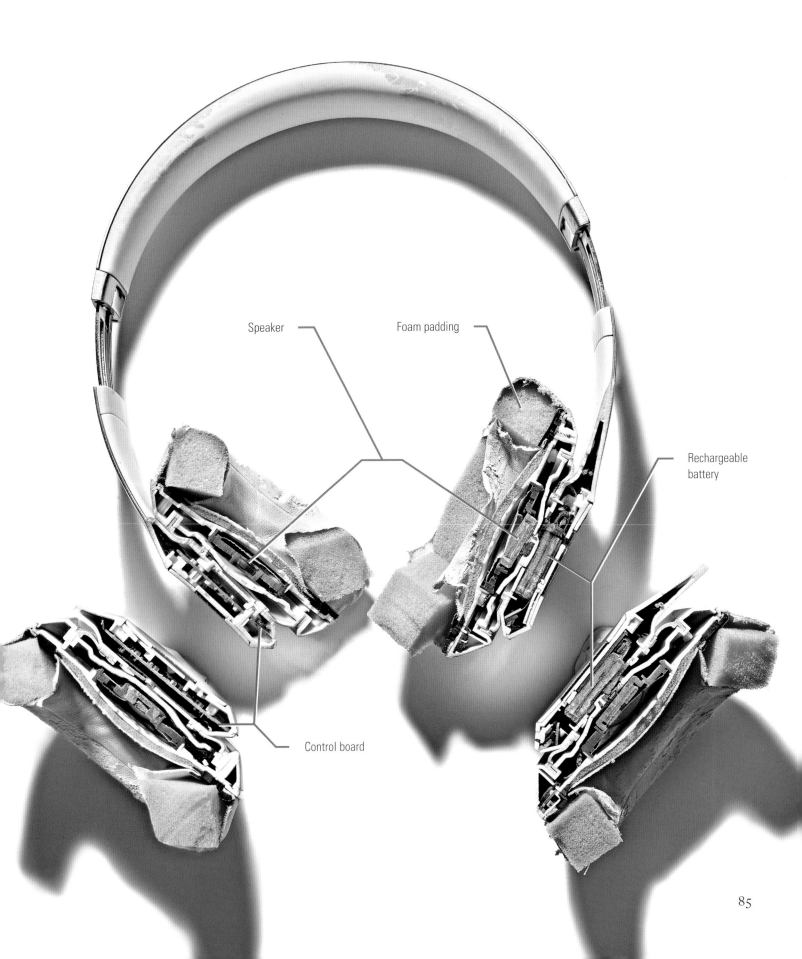

Speaker

Foam padding

Rechargeable battery

Control board

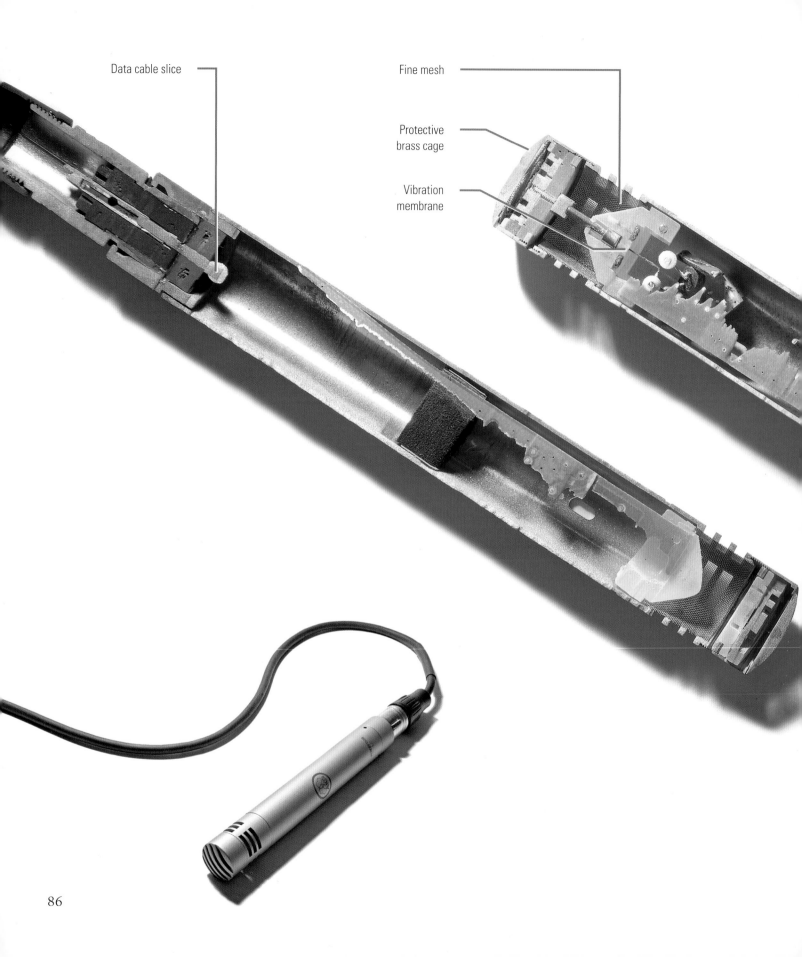

Data cable slice

Fine mesh

Protective
brass cage

Vibration
membrane

Studio Microphone

Microphones use a sensitive membrane to detect sounds waves and translate those vibrations into signals, which are then transmitted to an amplifier.

On this model, a fine mesh surrounds the recording membrane. This is used to help reduce or eliminate sharp sounds resulting from fast-moving air (for instance, the popping sound when speaking or singing the letter p). The mesh is in turn protected by a brass cage. The circuit board inside takes the analog signal from the recording membrane and converts the sound to digital information. This digital signal is sent out through the audio cable at the bottom of the microphone.

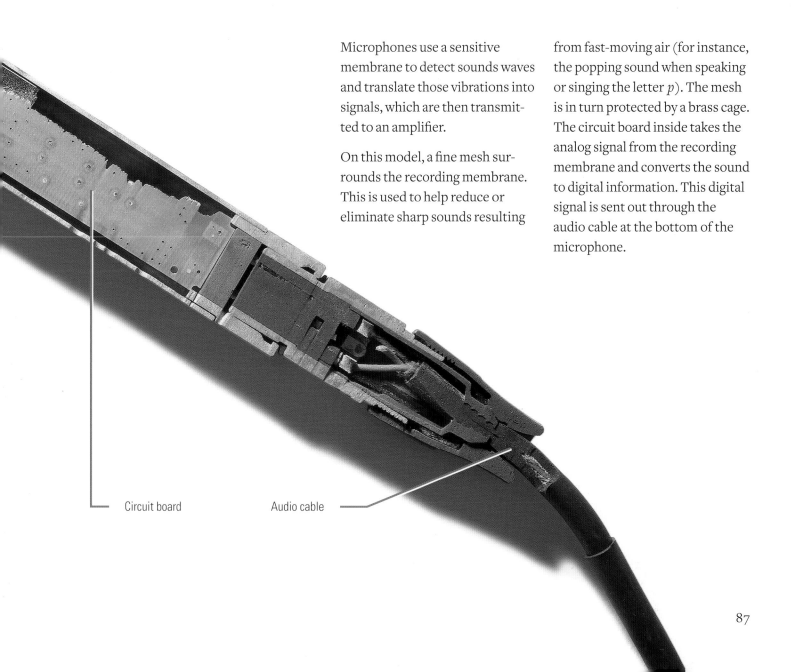

Circuit board

Audio cable

Guitar pedals change the sound output of the guitar, applying distortion, reverb, or other effects by processing the sound through a circuit board. The pedal rests on the floor and is activated by pressing on a button with your foot.

The effect that the pedal produces can be adjusted by potentiometer knobs at the top of the unit. The pedal is powered by a battery or a power input from a wall outlet.

A heavy metal plate, which adds weight to the pedal, combined with a rubberized bottom on the pedal keep it in place if you're rocking out.

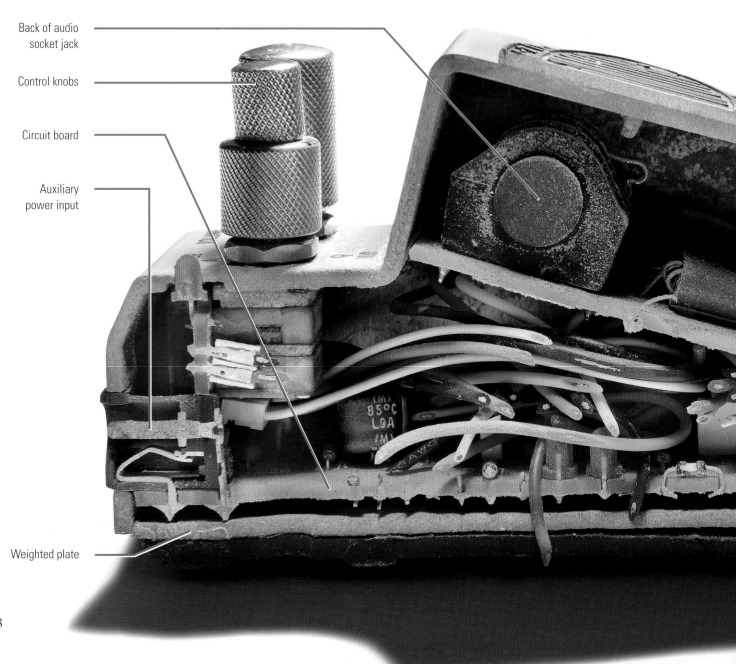

Back of audio socket jack

Control knobs

Circuit board

Auxiliary power input

Weighted plate

Guitar Effects Pedal

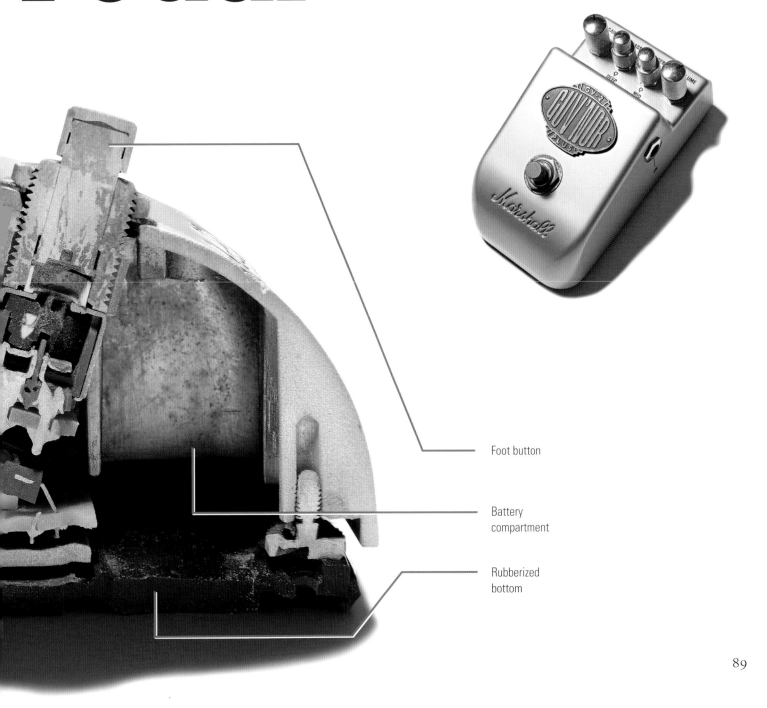

Foot button

Battery compartment

Rubberized bottom

Boom Box

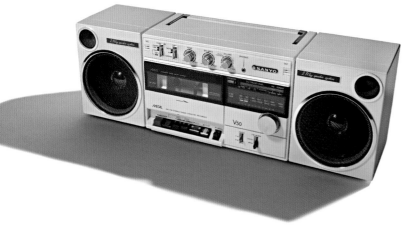

A deluxe version of the cassette recorder, the boom box plays audio cassettes and amplifies the sound through speakers on either side of the unit. A cassette is inserted into the deck which is then closed, aligning the cassette onto a motor that advances the reels. When the play button is pressed, a mechanical action pushes a magnetic reader against the magnetic tape to translate the tape to sound. When the fast-forward or reverse buttons are pressed, the magnetic reader is retracted from the tape and the motors spin the reels to move the tape to another part.

An equalizer board allows the sound produced to be modified to suit the listener's preference. A volume knob controls the amount of sound the speakers emit, transmitted through two ceramic magnet speakers and amplified by an electrical transformer.

Ceramic magnet speakers

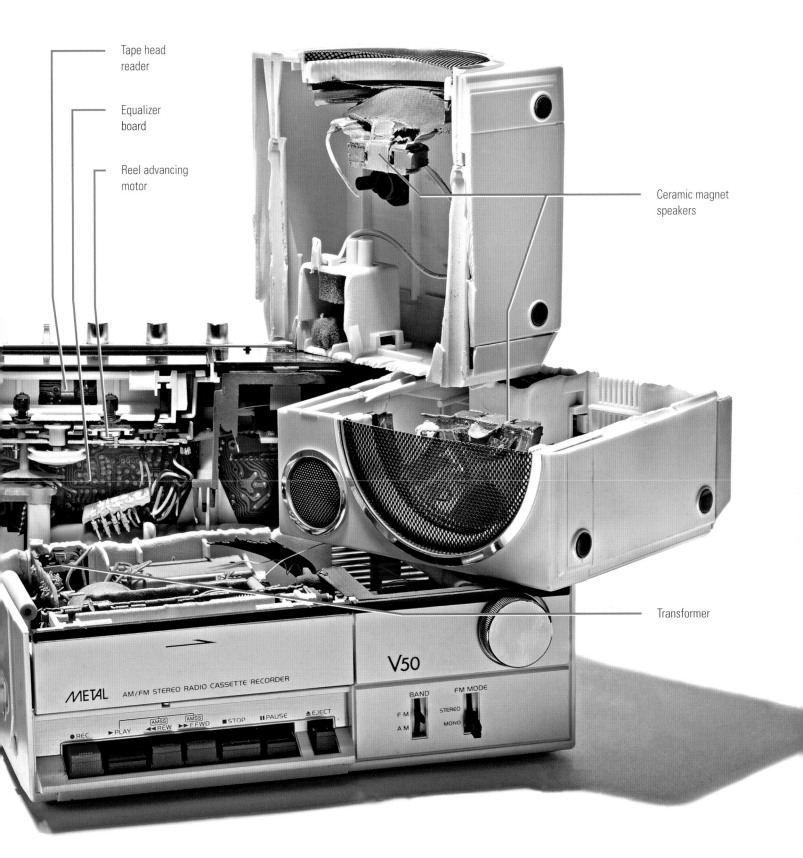

Tape head
reader

Equalizer
board

Reel advancing
motor

Ceramic magnet
speakers

Transformer

V50

METAL AM/FM STEREO RADIO CASSETTE RECORDER

● REC ► PLAY [AMSS] ◄◄ REW [AMSS] ►► F FWD ■ STOP ‖ PAUSE ▲ EJECT

BAND FM MODE

F M STEREO

A M MONO

TOYS AND GAMES

Video Game Console

As in other computer devices, the central processing unit (CPU) is the brain behind making these video game consoles work. The CPU is a microprocessor responsible for all the logic functions of the console, from memory allocation to input/output. These operations consume a lot of power, which heats up the CPU. To help keep it from overheating, a large aluminum-finned block called a heat sink is placed on top of the CPU. The heat sink has fins to spread the heat out more efficiently and is cooled with the help of a fan. A bus to the left of the heat sink transfers power and data between the console's components. To run games, this console uses compact discs placed in a tray and a laser to read the information on the disc and play the game.

The controller has buttons and joysticks that control movement on the screen. We can see that in the controller there is a long post connecting the button to the circuit board. This space makes the controller more comfortable to hold than if the button were directly on the circuit board of the controller.

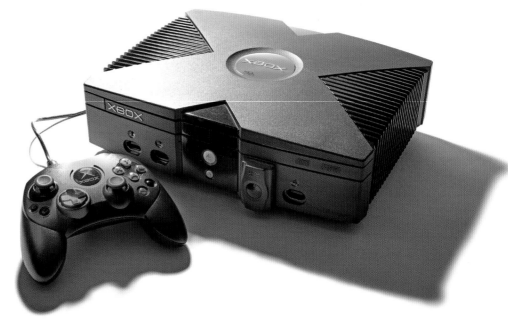

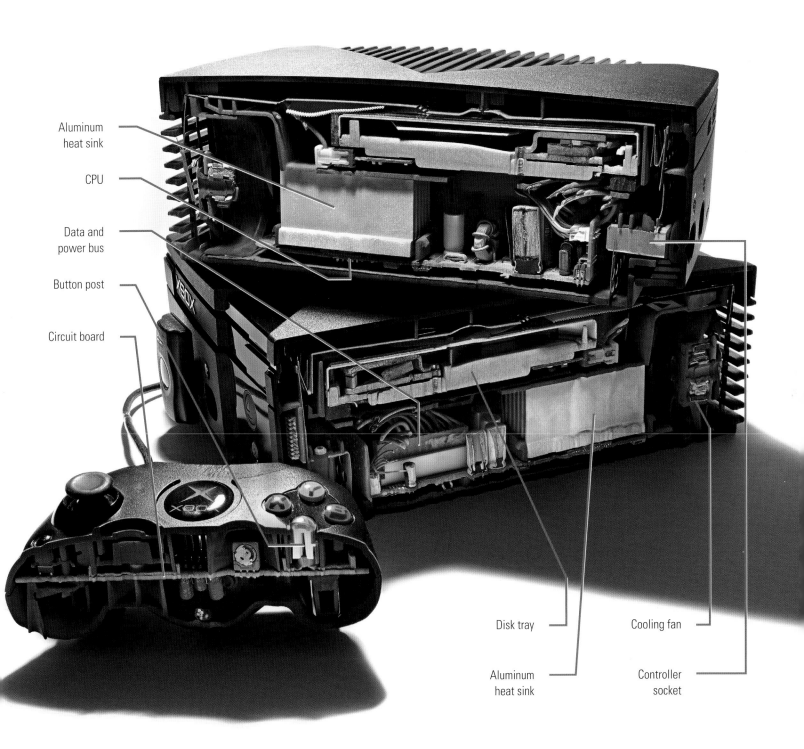

Aluminum
heat sink

CPU

Data and
power bus

Button post

Circuit board

Disk tray

Cooling fan

Aluminum
heat sink

Controller
socket

Gaming Joystick

Gaming joysticks take analog movements and translate them into a digital signal, telling the computer to move an object or character in the game. The basic technology inside joysticks has not changed much since they were introduced. New joysticks offer more controls, lights, and haptic feedback, but function the same as their predecessors.

Inside the base and stick of this model are potentiometers (variable resistors) that read the amount of resistance and direction when the joystick is moved. There are also buttons on the base and handle that can be assigned to specific actions in a game—all the information channels to the circuit board. The entire assembly is mounted to a sturdy steel plate in the bottom of the joystick, keeping it weighted and steady.

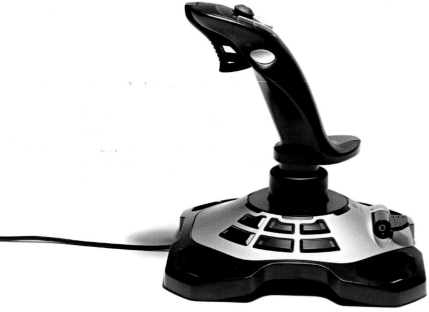

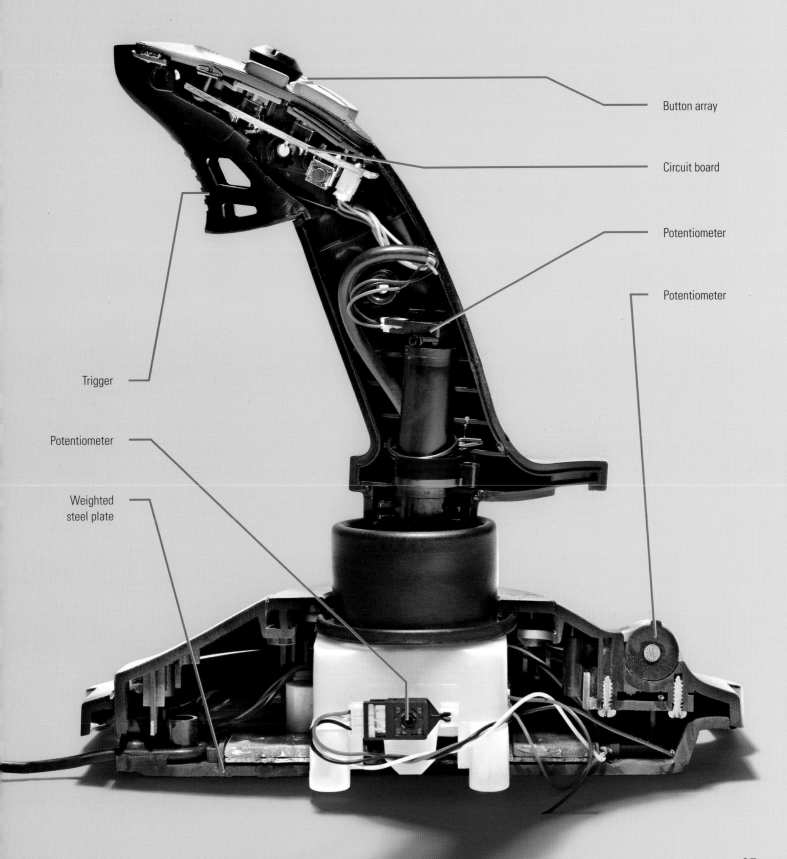

Button array

Circuit board

Potentiometer

Potentiometer

Trigger

Potentiometer

Weighted
steel plate

Furry Animatronic Toy

This dancing animatronic children's toy uses digital technology alongside analog mechanisms to make a sophisticated modern version of a teddy bear.

Inside, an electronic circuit board controls every movement and action this toy performs. Servomotors govern the position of the beak, eyelids, and ear movements, and pressure sensors embedded under the fur detect touch. Its eyes are small LCD displays that animate eye movement. The toy is operated by Bluetooth, but an aesthetic "antenna" at the top of the head, running through another circuit board, can be pressed to elicit different responses from the toy, such as laughter and dancing.

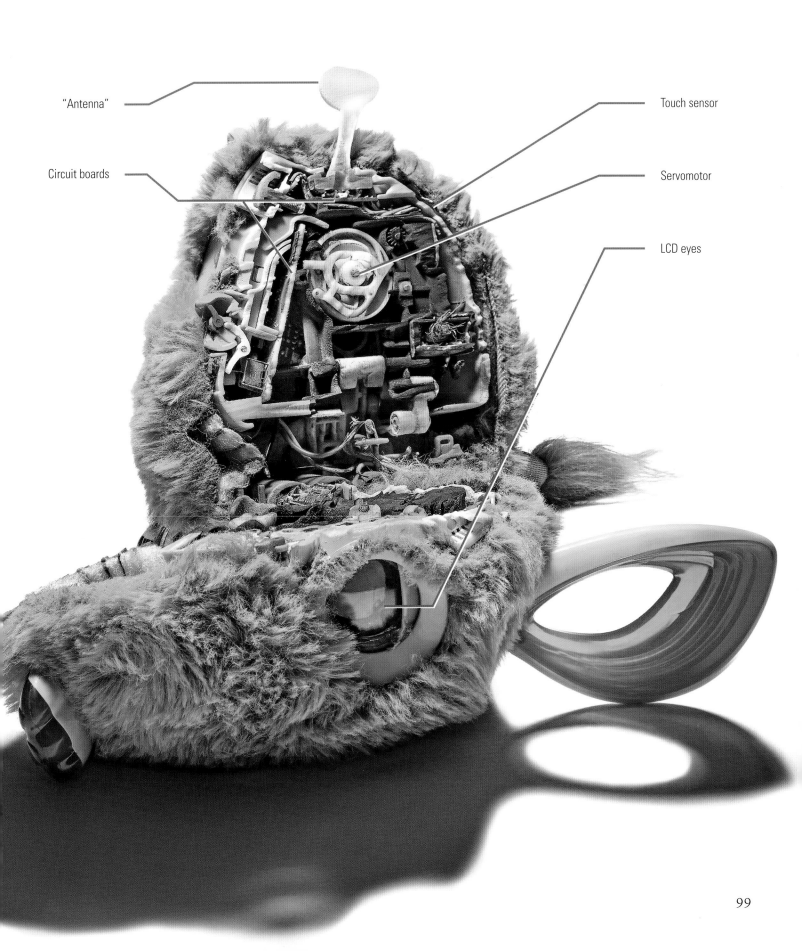

"Antenna"

Circuit boards

Touch sensor

Servomotor

LCD eyes

Novelty Singing Fish

This animatronic novelty was a big hit a few years ago, moving and singing when activated by either a push button or proximity sensor.

This toy has several motors inside that allow the body to articulate front and back, and the mouth to move in time with the music being played. The plastic housing inside is covered with foam padding to create the body shape, which is then covered by a textured silicone wrapping to give the illusion of a taxidermied fish. Once activated, the motors move the fish on the mounting plaque, all controlled by a circuit board hidden inside the plaque base.

BIG MOUTH BILLY BASS

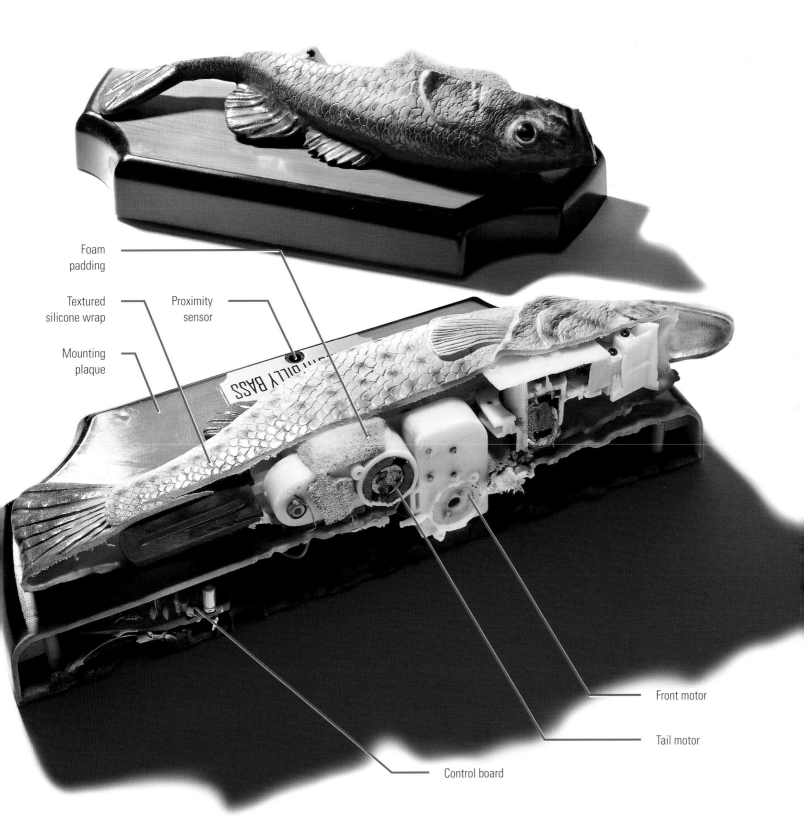

Foam
padding

Textured
silicone wrap

Proximity
sensor

Mounting
plaque

BIG MOUTH BILLY BASS

Front motor

Tail motor

Control board

Foam Dart Gun

Toy foam dart guns like this one are spring-loaded, using pneumatic power to launch dart projectiles. This model is a Gatling gun style, employing a cylindrical cluster of several barrels to successively fire foam darts quickly.

The darts are preloaded into each barrel of the Gatling cluster. The upper receiver moves the spring back, priming it to fire, and also advances the Gatling cluster to the next barrel. When the trigger is pressed, the spring releases its tension and pushes a plunger of air into the back of the dart and launches it out of the barrel. When the upper receiver is pulled back again the process is repeated until the Gatling cluster is out of darts.

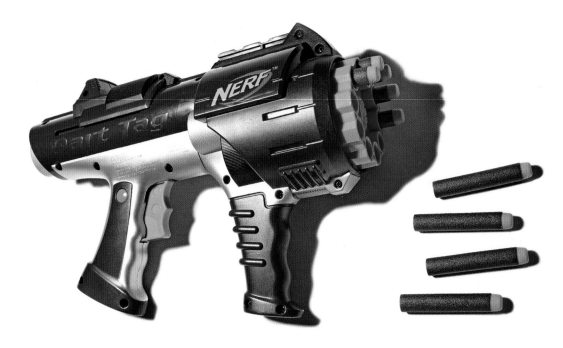

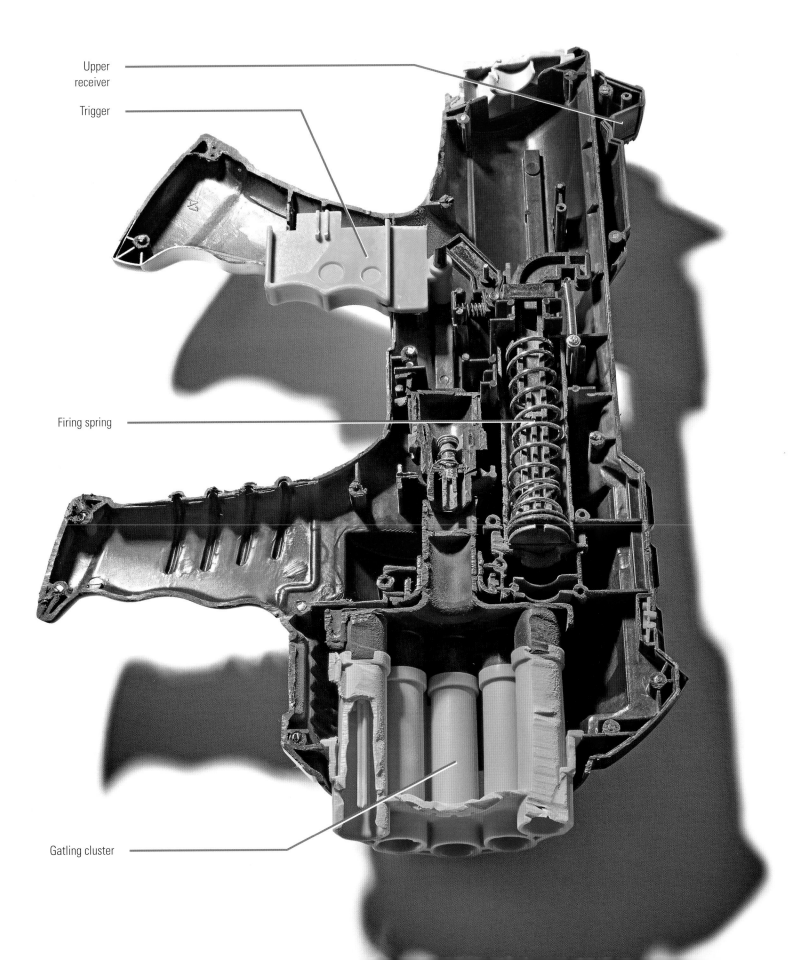

Upper receiver

Trigger

Firing spring

Gatling cluster

Guitar Game Controller

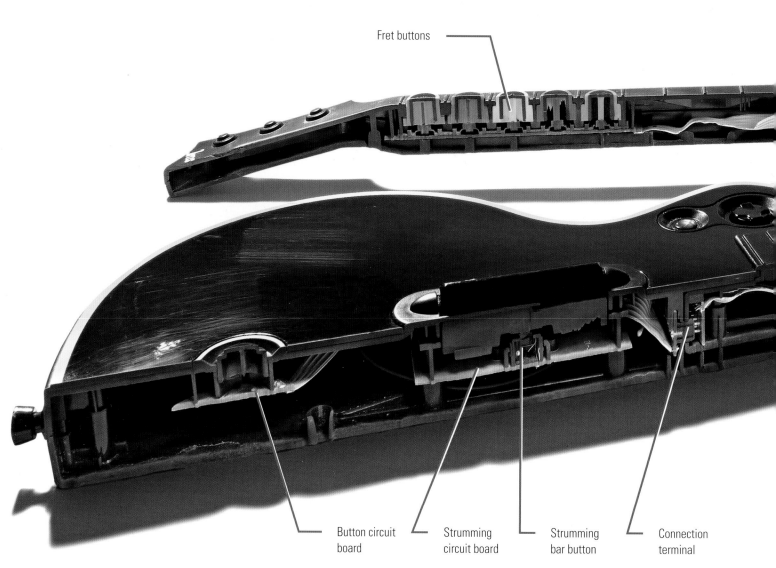

Fret buttons

Button circuit board

Strumming circuit board

Strumming bar button

Connection terminal

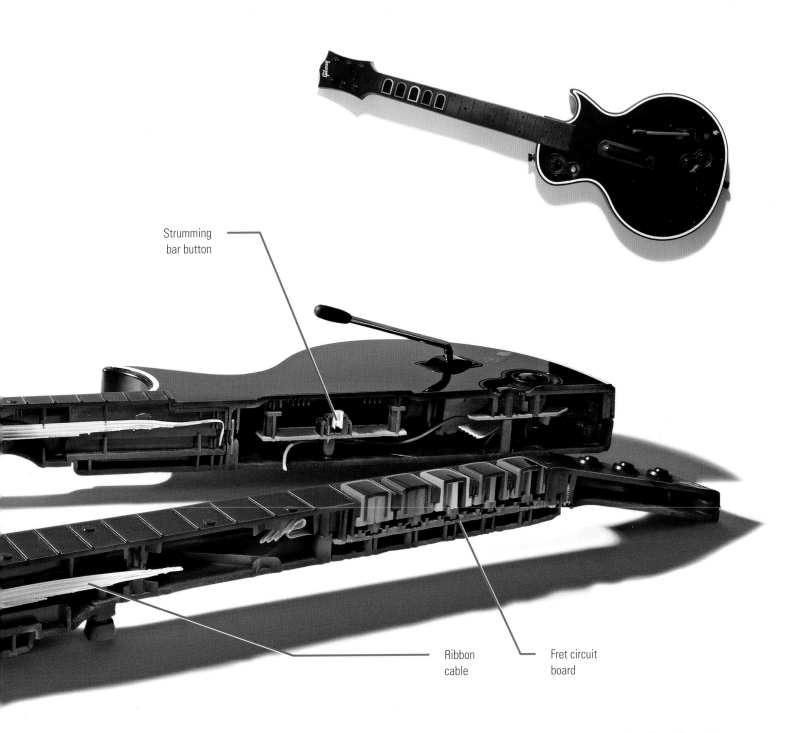

Strumming bar button

Ribbon cable

Fret circuit board

This scale model instrument replica is used as a controller to interact with a video game. The controller has button clusters on dedicated circuit boards, connected by ribbon cables, controlling various aspects of the device. In the neck, five colored buttons mimic finger placement on frets. Another button on a rocker switch on the body of the guitar mimics a strumming action.

The neck of the guitar controller is designed to separate from the body for storage, and there is a connection terminal where the neck meets the body.

Handheld Electronic Game

If you ever wondered how it's possible to make handheld electronic devices so inexpensive, it's because most of them aren't very different when you open them up, and they only use a few relatively standard components. The technology to make such devices has also been around for decades, allowing the process to be refined. This educational game device for kids is a good example to show just what's happening inside.

A relatively large portion of the inside of this device is taken up by the battery compartment. The width of the machine is used to house the screen and simple controls. The CPU, the brain of the device, is mounted directly to the circuit board. The board itself is streamlined and compact, with comparatively small, surface-mounted components (in this image we can see a few resistors mounted to the board, one of which has been cut in half).

This device uses a capacitive screen, which is a thin layer on the display screen that can read input from a stylus, which is hollow.

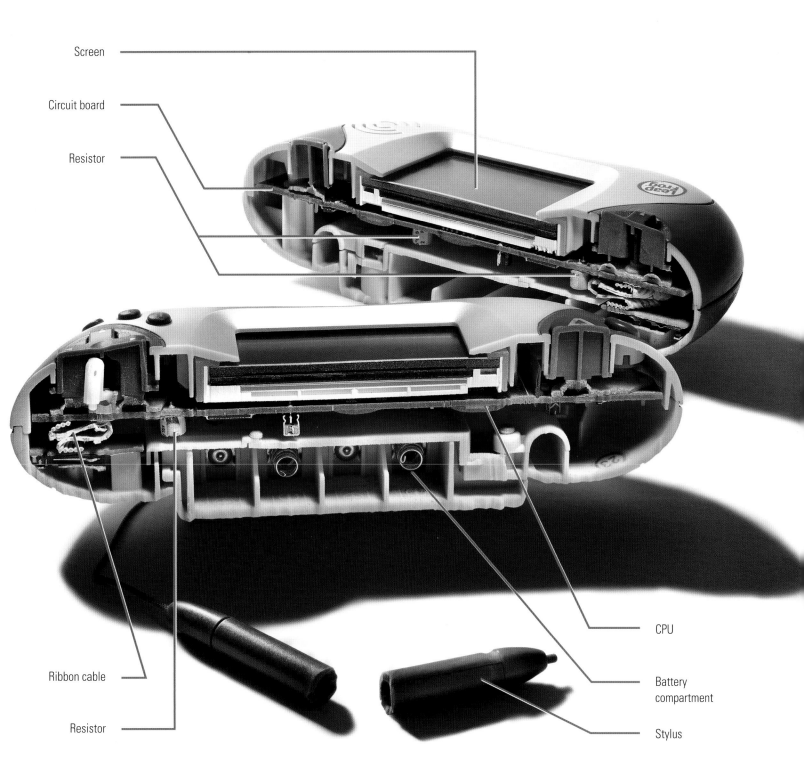

Screen

Circuit board

Resistor

Ribbon cable

Resistor

CPU

Battery compartment

Stylus

Nesting Dolls

These classic folk craft Russian nesting dolls are generally made from a soft pliable wood. These are made from pine. Each successively smaller doll is hand painted with delightful detail, often in traditional clothing.

Though not as complex as some of the other items in these pages, it's fun to see the consistency in concentric shapes of a handmade item. The milled connection lip between the top and bottom halves is particularly interesting, as this is the area that holds the two halves together.

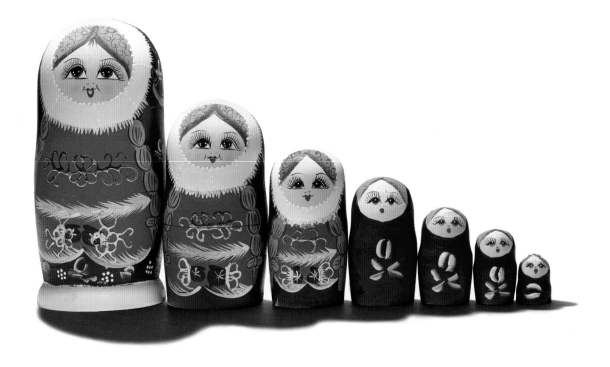

Pine wood

Milled
connection lip

Decorative
paint

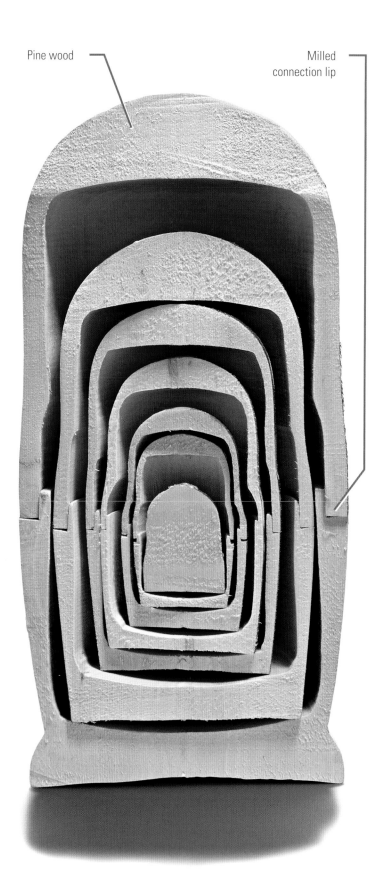

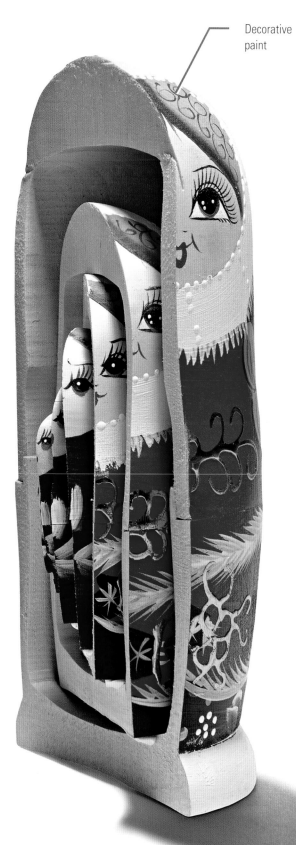

Fortune-Telling Eight Ball

The future is foretold using this mystical toy. Ask a question aloud, shake the ball, turn it so the window faces upward, and read the answer on the die face as it surfaces in the window. Each side of the hollow plastic die inside has a different statement that can be interpreted to address all kinds of possible questions.

The die floats in a chamber of dark liquid to obscure the answers on the sides other than the one floating to face the window. The chamber is filled through a small nipple at the top. Once filled, the chamber is installed inside the larger plastic shell decorated to look like an eight ball from billiards.

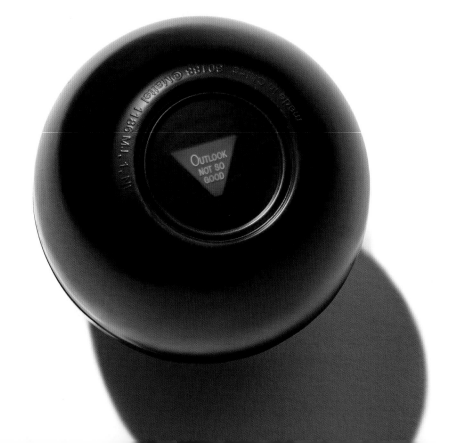

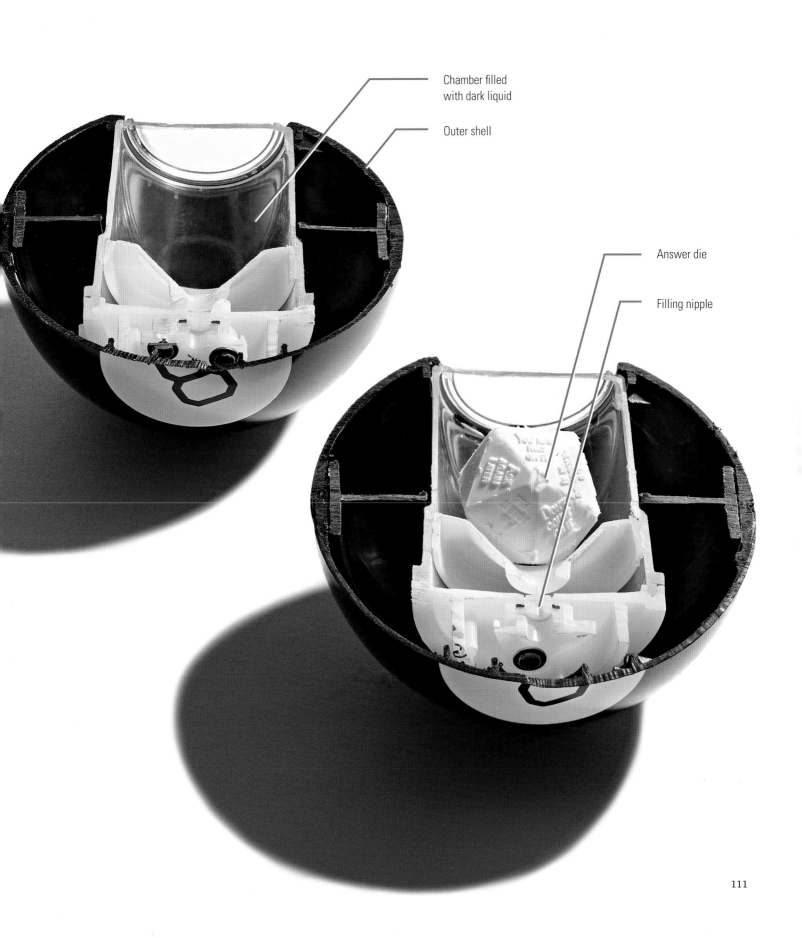

Chamber filled
with dark liquid

Outer shell

Answer die

Filling nipple

111

OTHER STUFF

Electric Stapler

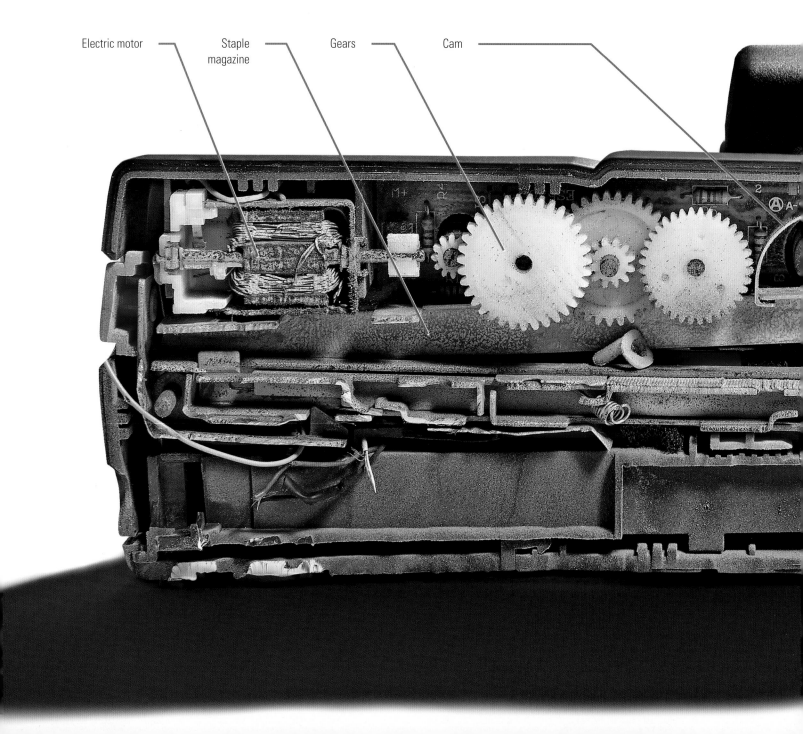

Electric motor Staple magazine Gears Cam

If you're looking for consistency in your stapling, or if you have a large volume of papers to staple, then the electric stapler is the answer.

The paper guideway features a sensor (not shown: obliterated when cutting) that detects if paper is inserted and pushes a staple into the chamber above and through the paper. A metal finger controlled by a motor-driven cam pushes just one staple down from the magazine, and voila, your documents have been stapled.

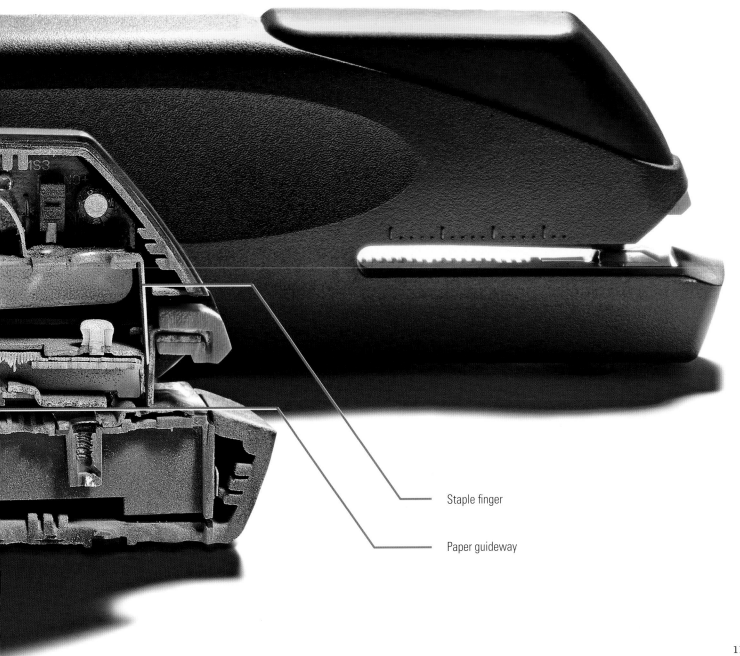

Staple finger

Paper guideway

Electric Pencil Sharpener

This pencil sharpener uses a heavy-duty electric motor to turn two helical sharpening blades around the end of a pencil to produce a sharp point. The blades move by way of a worm drive, an arrangement that helps keep the torque high to prevent the sharpeners from slipping off the drive train. When a pencil is inserted into the sharpener it presses against a switch, triggering the motor to spin until the pencil is removed. Pencil shavings fall from the blade sharpeners and are collected in a hopper below. The hopper is removable and can be emptied when full of shavings.

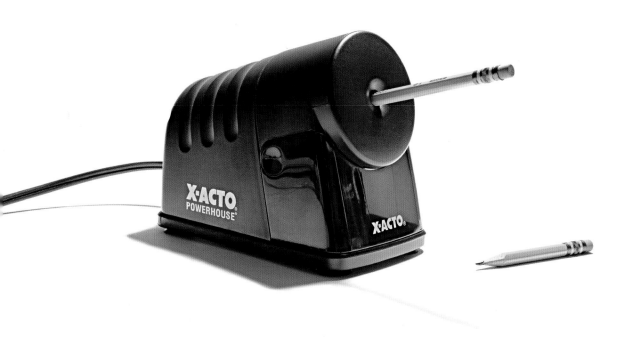

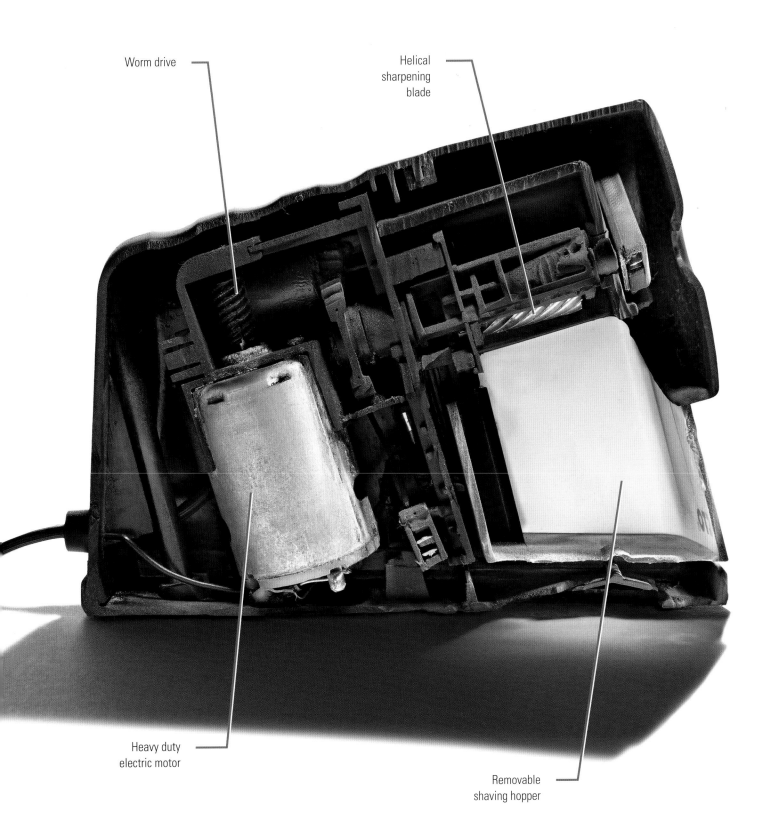

Worm drive

Helical
sharpening
blade

Heavy duty
electric motor

Removable
shaving hopper

Padlock

Most modern locks are built in a similar fashion, with a pinned locking mechanism secured inside a solid body. A key is inserted into the keyway and moves the key pins up to a shear line; these key pins correspond to driver pins on the other side of the sheer line. If the correct key is installed, the pins will correctly align and not be in the way of the shear line. The cylinder can then rotate freely, releasing the latch so the shackle can be opened. An incorrect key may be inserted, but if the pins are not set in the correct arrangement, they will cause interference with the shear line, and the cylinder will not rotate.

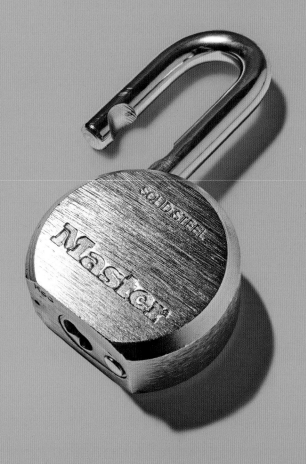

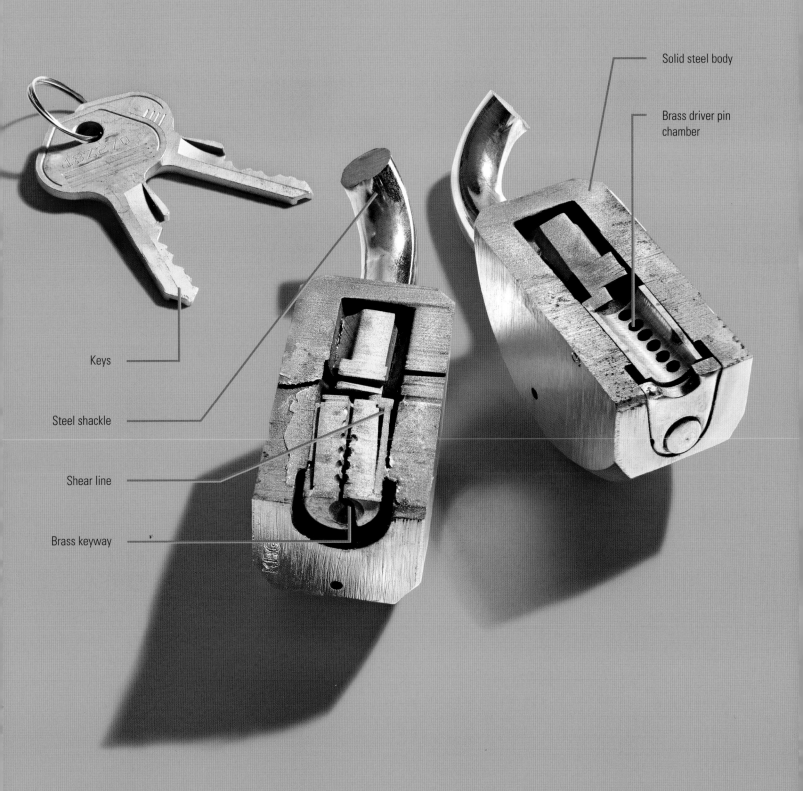

Solid steel body

Brass driver pin
chamber

Keys

Steel shackle

Shear line

Brass keyway

Giant Jawbreaker

Jawbreaker candies are made by coating a chewy center with successive layers of colored liquid sugar. This results in a color-changing experience as the candy layers are removed by licking. When a jawbreaker is neatly cut in half, every layer is revealed.

Jawbreaker candies are made by loading the chewy centers into a rotating drum and adding successive layers of colored liquid sugar to build up a coating.

The rotating drum prevents the candies from sticking together as the sugar coating cools. This process is repeated as many times as needed until the desired diameter is reached.

This jawbreaker is 3⅜ inches (8.5cm) in diameter and weighs a whopping 16 ounces (450g). It is among the largest commercially available—about six and a half times larger than the average jawbreaker.

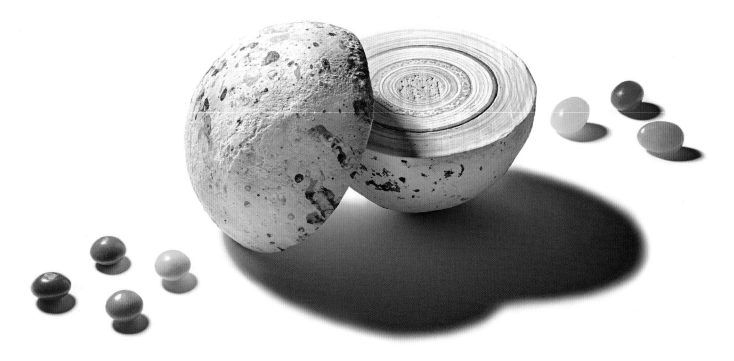

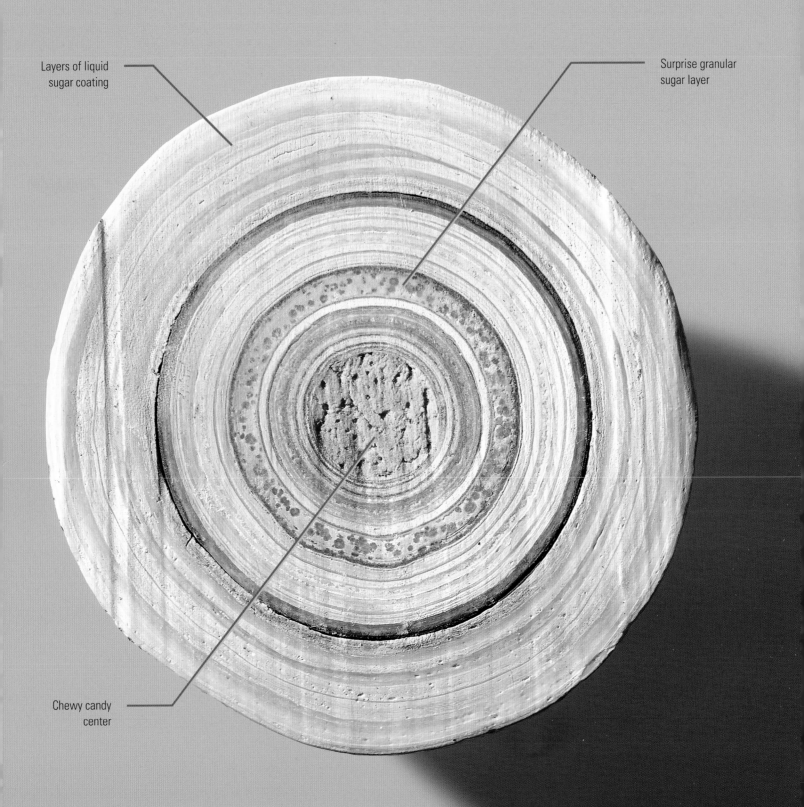

Layers of liquid
sugar coating

Surprise granular
sugar layer

Chewy candy
center

Liquid Fuel Lighter

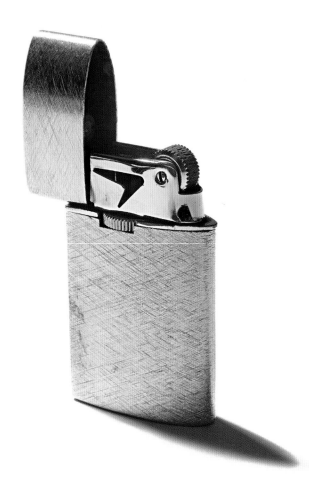

Unlike disposable lighters that typically employ butane fuel under pressure, refillable lighters can not only be refueled—hence the name—but also ignite fuel using a wick. Lighter fluid is added through a threaded fuel filling port at the bottom. The fuel is kept in a reservoir cavity in the body of the lighter. A foam baffle inside the reservoir prevents the fluid from sloshing around inside.

The wick dips into the fuel reservoir through the wick chamber and, using capillary action, moves a steady stream of lighter fluid upward toward the flint and striker wheel. When the wheel sparks against the flint, it ignites the top of the fuel wick and creates a flame. The flint is eventually worn down to nothing after repeated use. Additional flints are stored in a hopper below the active flint, automatically loaded into position by a spring when the flint above is spent. The flint hopper can be refilled through an opening in the bottom, keeping the lighter ready for a spark.

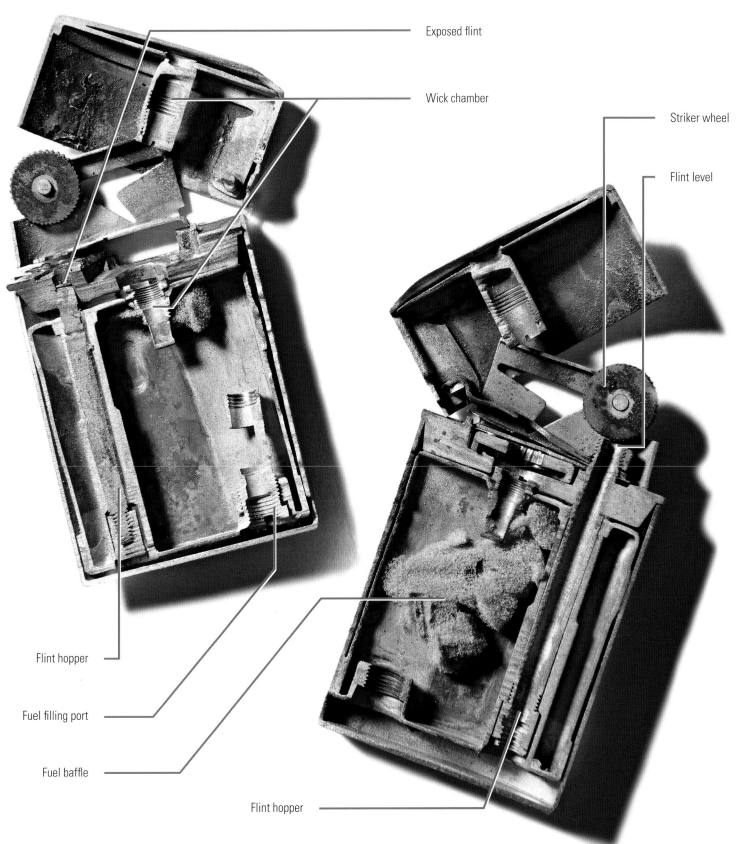

Exposed flint

Wick chamber

Striker wheel

Flint level

Flint hopper

Fuel filling port

Fuel baffle

Flint hopper

123

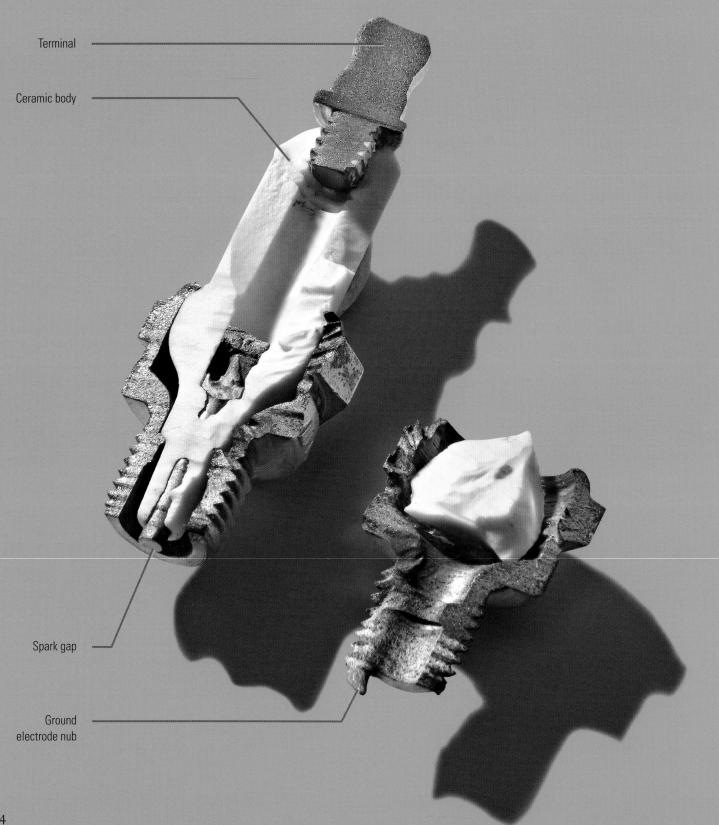

Terminal

Ceramic body

Spark gap

Ground
electrode nub

Spark Plug

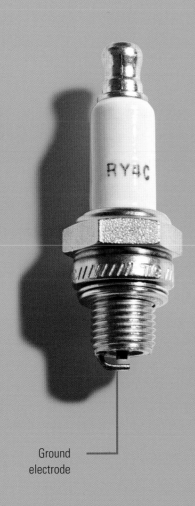

Ground
electrode

Spark plugs fit into the cylinder head of an internal combustion engine and ignite compressed aerosolized gas with an electric spark. Electrical energy from an ignition coil is transmitted to the terminal end of the spark plug. The energy travels down the center cavity inside the plug to the spark gap at the bottom of the plug. The electrical charge jumps the gap to the ground electrode and creates a spark. To insulate the space between the terminal and the spark gap, the body of a spark plug is made of electrically insulating ceramic.

A cylinder head moves up a compression chamber toward the spark plug, compressing an air and gas mixture as the cylinder rises. When the cylinder reaches its apex, the spark plug receives maximum current and a spark jumps the gap and ignites the compressed mixture inside the compression chamber. The resulting explosion pushes the cylinder head back down the chamber. That force is translated to the crankshaft and results in rotation movement, which can be harnessed by means of a car or lawnmower.

Oil Filter

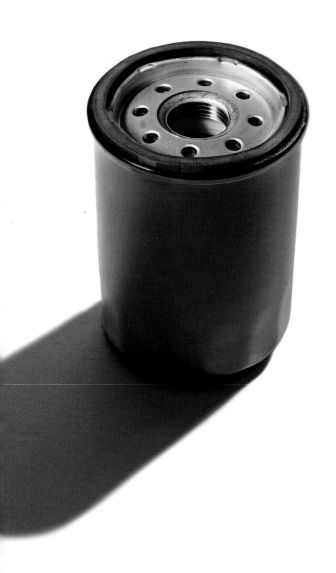

An oil filter is used in combustion engines to help remove contaminants from the engine's oil that can accumulate over time. Oil is used with combustion engines as a lubricant and to regulate heat, and such an engine can't operate without it. Over time, tiny particles of metal from engine wear or carbon debris from combustion accumulate in motor oil and need to be filtered out to prevent wearing on any surfaces inside the engine, avoiding excess wear on the oil pump used to circulate the oil around the engine.

Oil is pumped into the filter through the array of openings near the perimeter and into the outer chamber of the filter body. The oil is then forced through the filter material to remove fine particles, and then through the inner mesh, which is designed to keep the filter material out of the inner chamber. Oil travels through the center of the filter and out the large central opening and into the engine. There are gaskets around the opening of the filter, one around the outside to keep oil from spilling out, and a second gasket around the central opening to keep the filtered oil separate from the unfiltered oil. In case there is a severe blockage in the filter and the oil cannot be pumped through, there is a bypass valve that allows unfiltered oil through and lets the engine continue to function.

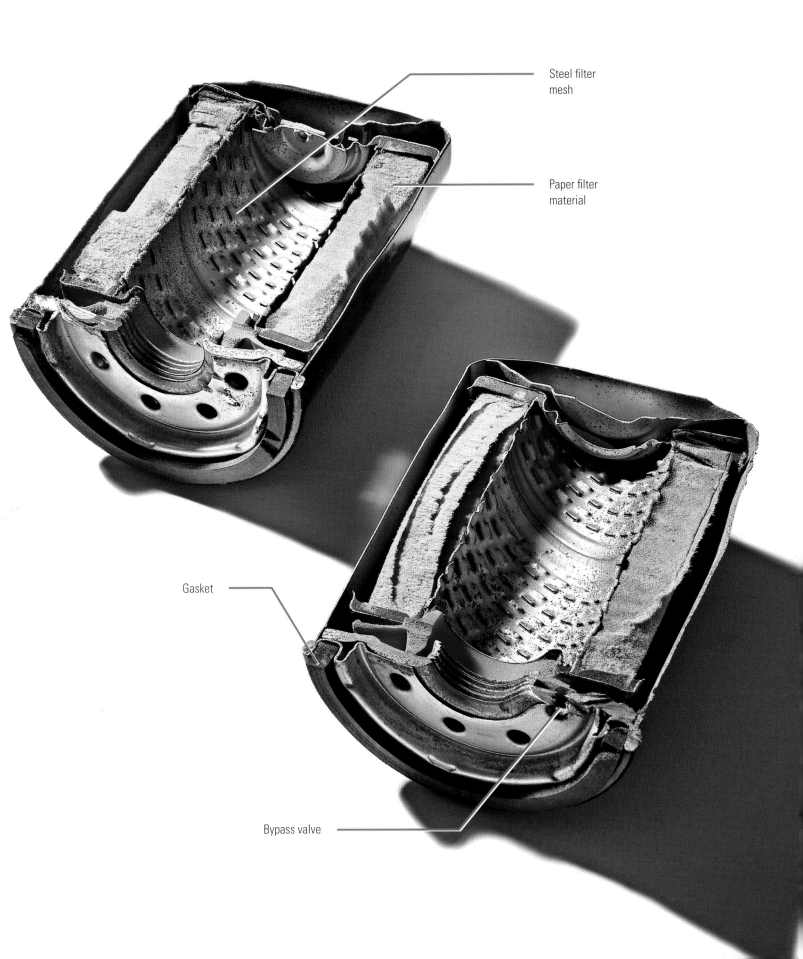

Steel filter
mesh

Paper filter
material

Gasket

Bypass valve

Motorcycle Helmet

This surprisingly minimal makeup of a motorcycle helmet shows just how effective some foam can be in terms of providing a safety shield. A hard plastic polycarbonate outer shell is thermoformed to create a tough exterior, protecting the thick, dense foam core. At the neck, there is also soft cushioning to keep the skull comfortable against the rigid foam core. This cushioning can be modified with smaller patches of light foam to meet the specific needs of a rider's head shape. Air vents at the front and on top of the helmet allow for air circulation inside.

The opening at the front of the helmet is protected by a clear shatter-resistant plastic shield, which can be raised and lowered by hand. These shields are designed to be removable in case a shield is scratched or damaged. Inside, padding keeps the helmet snug on your head, and a chin strap keeps it in place when riding.

Clear plastic shield Air vents

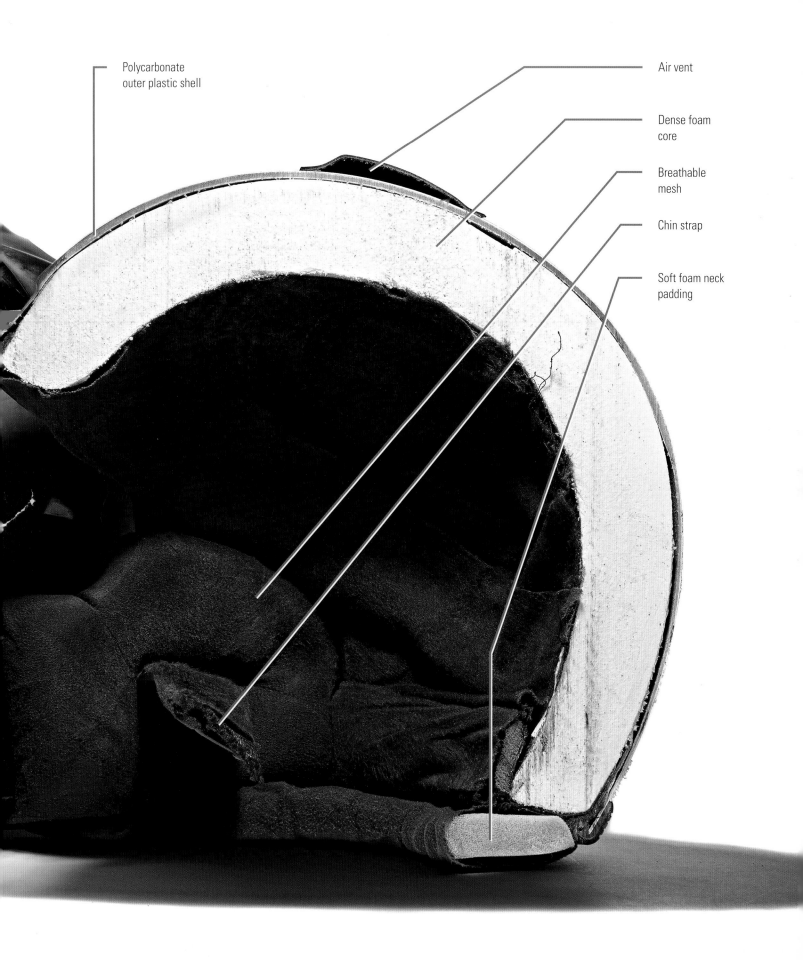

Polycarbonate
outer plastic shell

Air vent

Dense foam
core

Breathable
mesh

Chin strap

Soft foam neck
padding

Paper Shredder

Paper shredders protect your unwanted documents from prying eyes by rendering whole sheets of paper into tiny bits by way of cutting rollers.

Shredders are powered by a high-torque electric motor, capable of powering through stacked paper and credit cards without getting bogged down. The shredding rollers have teeth in alternating rows to not only grip the paper but shred in an erratic fashion, making any reclamation of the shredded documents extremely difficult. The white spacers separate the teeth and allow gaps for paper to expand into while being shredded, reducing the likelihood of a paper jam.

The top shredding unit is removable from the bin below. The majority of the space inside the paper shredder is a cavity to receive the shredded paper, and a removable container to dump the waste paper once the bin is full.